CONTENTS

CHAPTER ONE DADA ERUPTS

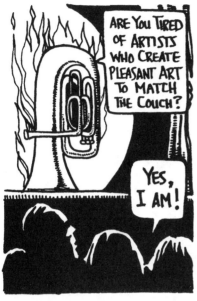

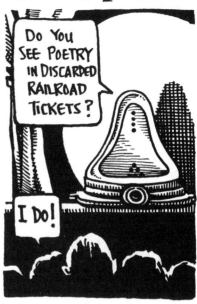

Then you may be ready to be a Dada or Surrealist.

To get started, let's assume the right mood, which requires some adjustment of your modern approach. So we will head to Zurich, Switzerland, in 1916.

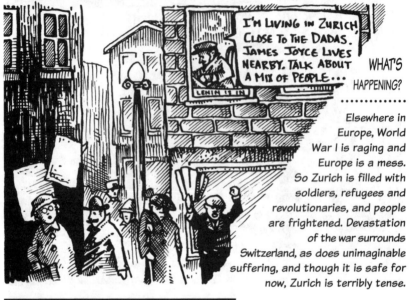

I'M LIVING IN ZURICH, CLOSE TO THE DADAS. JAMES JOYCE LIVES NEARBY. TALK ABOUT A MIX OF PEOPLE...

LENIN IS IN

WHAT'S HAPPENING?

Elsewhere in Europe, World War I is raging and Europe is a mess. So Zurich is filled with soldiers, refugees and revolutionaries, and people are frightened. Devastation of the war surrounds Switzerland, as does unimaginable suffering, and though it is safe for now, Zurich is terribly tense.

Now let's head down the street to the Dada's hangout,

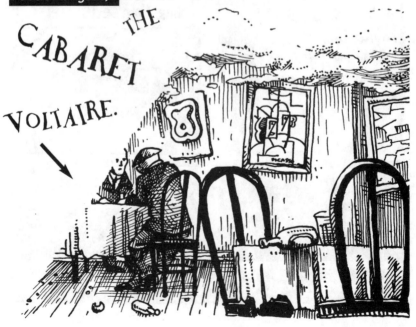

THE CABARET VOLTAIRE.

PICASSO

WHAT IS BOURGEOIS?"

IT MEANS "MIDDLE CLASS" BUT WITH DEROGATORY CONNOTATIONS. NO CULTURE, NO TASTE, ONLY MONEY.

WAS THAT QUESTION BOURGEOIS?

JUST WHO ARE THESE PEOPLE?

The Dadas may or may not introduce themselves, depending on how bourgeois they find us, so here's an introduction:

ZURICH CAST OF
MAIN CHARACTERS

(a.k.a. - The Founders of Dada)

TRISTAN TZARA (Romanian), a student of literature and philosophy, whose adopted name means "sad in country."

{3

HUGO BALL (German), the founder of the Cabaret Voltaire. A former theater director, he's seen the war (although he did not fight; he was rejected from military service on medical grounds), and hates it. A conscientious objector, he's an idealist and doesn't stay with the group long.

EMMY HENNINGS (German), actress, dancer, cabaret singer, expert forger, and Ball's companion.

RICHARD HUELSENBECK (German), a medical student who was drafted and fled to Switzerland to study medicine.

MARCEL JANCO (Romanian). Friend of Tzara and a student of architecture, he becomes known for his Dada masks.

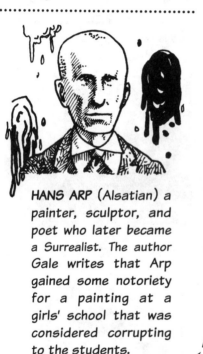

4}

HANS ARP (Alsatian) a painter, sculptor, and poet who later became a Surrealist. The author Gale writes that Arp gained some notoriety for a painting at a girls' school that was considered corrupting to the students.

And that's the original group. This is Ball's venue, and he's promoting a Dada happening for this evening.

The Dadas enjoyed hijinx, irony, and paradox—they posed the question of whether Dada is art or fire insurance, nothing or everything, art or anti-art?

Ball's the one who's set up the cabaret, which has been going on for about three months now.

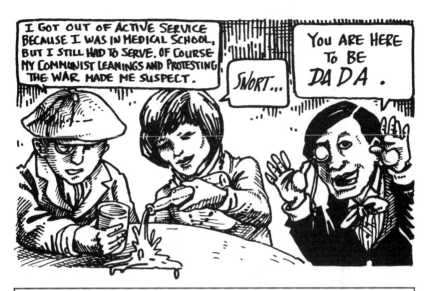

I GOT OUT OF ACTIVE SERVICE BECAUSE I WAS IN MEDICAL SCHOOL, BUT I STILL HAD TO SERVE. OF COURSE MY COMMUNIST LEANINGS AND PROTESTING THE WAR MADE ME SUSPECT.

SNORT...

YOU ARE HERE TO BE DADA.

The Dadas claimed to know all about Enlightenment ideas— Reason. Rationality. Morality. The arts ennoble people—the arts are supposed to make people better human beings, right? But the Dadas looked around Europe and saw death, destruction, and inventions designed for the purposes of death and destruction.

IF I CRY OUT: IDEAL, IDEAL, IDEAL, KNOWLEDGE, KNOWLEDGE KNOWLEDGE, BOOMBOOM, BOOMBOOM, BOOMBOOM, I HAVE GIVEN A PRETTY FAITHFUL VERSION OF PROGRESS, LAW, MORALITY!

DADA WORLD WITHOUT END, DADA REVOLUTION WITHOUT BEGINNING. DADA, YOU FRIENDS AND ALSO-POETS, ESTEEMED SIRS, MANUFACTURERS, AND EVANGELISTS!

TALKING HEADS, O

WE'RE GOING BOOM, BOOM, BOOM, AND THAT'S THE WAY WE LIVE.

WE HAVE HAD ENOUGH OF THE INTELLIGENT MOVEMENTS THAT HAVE STRETCHED BEYOND MEASURE OUR CREDULITY IN THE BENEFITS OF SCIENCE. WHAT WE WANT NOW IS *SPONTANEITY*.

DA DA DA DA DA DA DA DA DA DA DA DA DA

Tzara's reaction is a state of mind that was common: many international youths and artists recognized this irrational response to the turbulent politics and war of the time.

8}

The Dadas are young, passionate, and angry. They have a point: all this reasonable, rational talk from the nice normal middle class buzzes around them while people are hungry, hurting and still dying horrible deaths. The middle class is talking about God and country, flags and churches, while the devastation rages around them. It's crazy. But the middle class, if they know anything about Dada, think it's nonsense.

So, if a group of clearly irrational people have decided that YOU are the one with a problem, maybe it's better not to be like them at all. The Dadas prefer at this point to form their own identity, preferably as different from the middle class as possible. Maybe the irrational is better than the rational, given what's happening around Europe. That's what the Dadas are talking about. They're sad and angry. They have resorted to tactics of shock and irony, and the irrational has become a frame of mind set in opposition to the "devil machinery" of World War I.

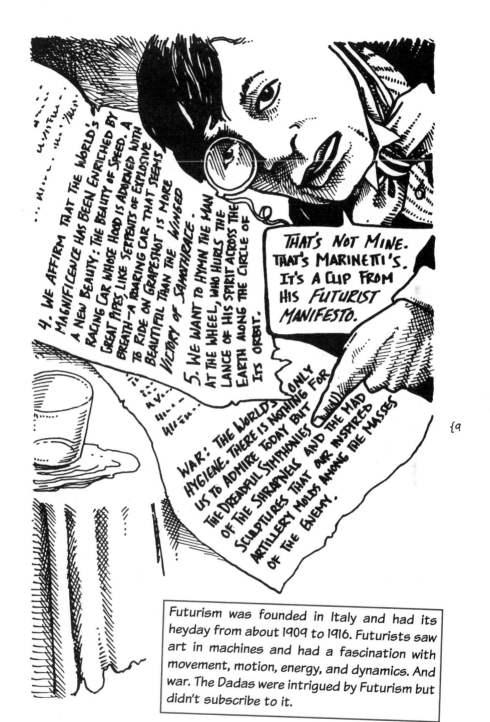

4. WE AFFIRM THAT THE WORLD'S MAGNIFICENCE HAS BEEN ENRICHED BY A NEW BEAUTY: THE BEAUTY OF SPEED. A RACING CAR WHOSE HOOD IS ADORNED WITH GREAT PIPES, LIKE SERPENTS OF EXPLOSIVE BREATH—A ROARING CAR THAT SEEMS TO RIDE ON GRAPESHOT IS MORE BEAUTIFUL THAN THE WINGED VICTORY OF SAMOTHRACE.

5. WE WANT TO HYMN THE MAN AT THE WHEEL, WHO HURLS THE LANCE OF HIS SPIRIT ACROSS THE EARTH ALONG THE CIRCLE OF ITS ORBIT.

THAT'S NOT MINE. THAT'S MARINETTI'S. IT'S A CLIP FROM HIS *FUTURIST MANIFESTO.*

WAR: THE WORLD'S ONLY HYGIENE. THERE IS NOTHING FOR US TO ADMIRE TODAY BUT THE DREADFUL SYMPHONIES OF THE SHRAPNEL AND THE MAD SCULPTURES THAT OUR INSPIRED ARTILLERY MOLDS AMONG THE MASSES OF THE ENEMY.

{9

Futurism was founded in Italy and had its heyday from about 1909 to 1916. Futurists saw art in machines and had a fascination with movement, motion, energy, and dynamics. And war. The Dadas were intrigued by Futurism but didn't subscribe to it.

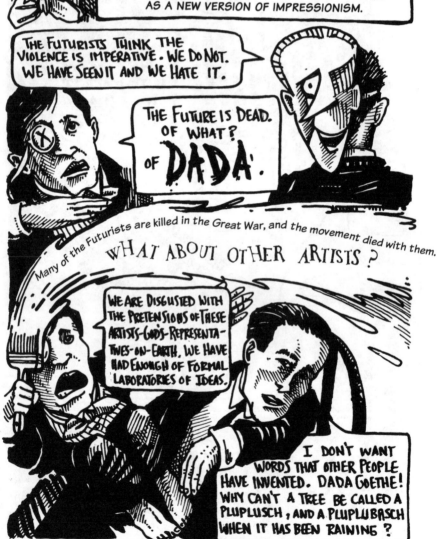

LIFE IS SEEN IN A SIMULTANEOUS CONFUSION OF NOISES, COLOURS AND SPIRITUAL RHYTHMS WHICH IN DADA ART ARE IMMEDIATELY CAPTURED BY THE SENSATIONAL SHOUTS AND FEVERS OF ITS BOLD EVERYDAY PSYCHE AND IN ALL ITS BRUTAL REALITY. THIS IS THE DIVIDING LINE BETWEEN DADAISM AND ALL OTHER ARTISTIC TRENDS AND ESPECIALLY FUTURISM WHICH FOOLS HAVE VERY RECENTLY INTERPRETED AS A NEW VERSION OF IMPRESSIONISM.

THE FUTURISTS THINK THE VIOLENCE IS IMPERATIVE. WE DO NOT. WE HAVE SEEN IT AND WE HATE IT.

THE FUTURE IS DEAD. OF WHAT? OF DADA.

Many of the Futurists are killed in the Great War, and the movement died with them.

WHAT ABOUT OTHER ARTISTS?

WE ARE DISGUSTED WITH THE PRETENSIONS OF THESE ARTISTS-GODS-REPRESENTA-TIVES-ON-EARTH. WE HAVE HAD ENOUGH OF FORMAL LABORATORIES OF IDEAS.

I DON'T WANT WORDS THAT OTHER PEOPLE HAVE INVENTED. DADA GOETHE! WHY CAN'T A TREE BE CALLED A PLUPLUSCH, AND A PLUPLUBASCH WHEN IT HAS BEEN RAINING?

Ball wanted to dispense with a language that he claimed had been made stale and obsolete by journalism. Ball preferred to use "sound poems" to be performed by Dada stage artists. The key to the sound poem is to estrange language from its traditional use. In the sound poem, words are spliced into individual phonetic symbols that rely on repetition and rhythm to create what the Dadas called "sound pictures."

Then there is the question of what IS Dada? What does it mean?

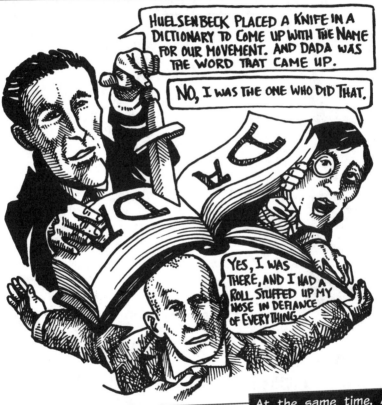

The Dadas disagreed with one another about art, politics, and general Dada events, but at times these disagreements seemed to spur greater creativity. Arp inspired the role of chance in art in his work, "Untitled (Collage with Squares Arranged According to the Laws of Chance)."

At the same time, Arp celebrated the harmony of organic structures by the Post-Impressionist Cezanne. Arp continues Cezanne's legacy in his painted wood object entitled *Relief Dada*.

At times, critics like to pigeonhole certain artists as part of one movement or another. When viewing any group of artists it is important not to get too caught up in the "isms" of art, and recognize each artist is an *individual* working within the context of a group. Many Dadas wanted to blow up these "isms" while paradoxically being inspired by them.

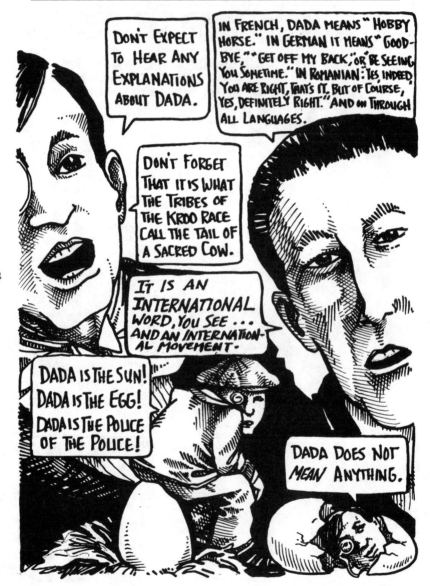

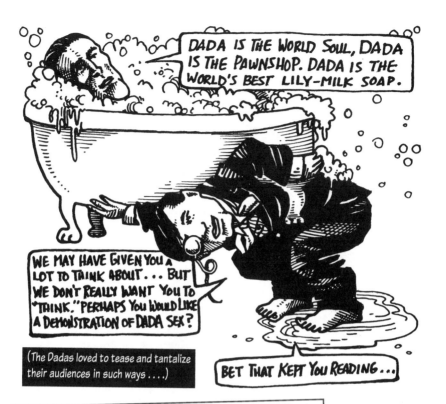

DADA IS THE WORLD SOUL, DADA IS THE PAWNSHOP. DADA IS THE WORLD'S BEST LILY-MILK SOAP.

WE MAY HAVE GIVEN YOU A LOT TO THINK ABOUT... BUT WE DON'T REALLY WANT YOU TO "THINK." PERHAPS YOU WOULD LIKE A DEMONSTRATION OF DADA SEX?

(The Dadas loved to tease and tantalize their audiences in such ways....)

BET THAT KEPT YOU READING...

It is important to realize that this book is *not* Dada. This book is telling you *about* Dada. The Dadas wouldn't like that. They wanted Dada to be about:

LIFE!

BEING ALIVE! IRONY! PROVOKING ACTION!

NIHILISM! SWEEPING THINGS CLEAN!

ABANDONING THE PAST! CHANCE! BEING HUMAN!

The Dadas don't like nice bourgeois writers writing about their movement, and they certainly wouldn't like nice bourgeois readers "getting" it.

ALTHOUGH WE DID LIKE ATTENTION, FROM THE BOURGEOISIE OR OTHERWISE.

Throw the book away, they might say. And be Dada.

THE TRUE DADAS ARE SEPARATE FROM DADA

Maybe now you have the sense that:

DADA IS A STATE OF MIND. THAT IS WHY IT TRANSFORMS ITSELF ACCORDING TO RACES AND EVENTS... THE FIRST TO TENDER HIS RESIGNATION FROM THE DADA MOVEMENT *WAS MYSELF*. EVERYBODY KNOWS THAT DADA IS NOTHING. I BROKE AWAY FROM DADA MYSELF AS SOON AS I UNDERSTOOD THE IMPLICATIONS OF *NOTHING*.

HANS RICHTER was one of the Dadas. He documented many Dada events in his book, *Dada: Art and Anti-Art.*

THAT'S ME — I HAVE A LOT TO SAY ABOUT DADA. I WAS ALSO A FILMMAKER.

QUACK.

BOLL →

TZARA EVENTUALLY DROVE ME OUT OF THE MOVEMENT. I LEFT DADA AND JOINED A MONASTERY.

This book will focus less on dates and facts, since the Dadas wouldn't be too excited about them anyway, and more on helping you understand TONE and MOOD and SPIRIT of the movement.

WHY?

The Dadas didn't *want* their work to be documented. To their way of thinking, work that's documented becomes too stale and too easily claimed by the bourgeois, where it not only becomes acceptable but also loses its spontaneity and vibrancy—qualities that made it Dada in the first place.

HISTORIAN →

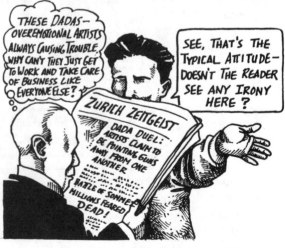

YOU DADAS CAN BE SO CONTRADICTORY — AND YOU SEEM TO DO IT ON PURPOSE! I AM NOT SURE IF I CAN TRUST YOUR ACCOUNTS! HOW WILL WE EVER KNOW WHAT REALLY HAPPENED?

TZARA CALLS DADA:

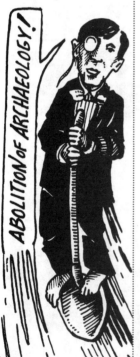

ABOLITION OF ARCHAEOLOGY!

The Dadas did indeed have wildly differing accounts of "what really happened" regarding various significant events in the movement, but seemed to make little effort to clarify the matters—and, in fact, seemed to enjoy making their stories MORE puzzling at times.

THESE DADAS— OVEREMOTIONAL ARTISTS ALWAYS CAUSING TROUBLE, WHY CAN'T THEY JUST GET TO WORK AND TAKE CARE OF BUSINESS LIKE EVERYONE ELSE?

ZURICH ZEITGEIST

DADA DUEL: ARTISTS CLAIM TO BE POINTING GUNS AWAY FROM ONE ANOTHER

BATTLE OF SOMME: MILLIONS FEARED DEAD!

SEE, THAT'S THE TYPICAL ATTITUDE— DOESN'T THE READER SEE ANY IRONY HERE?

In *Dada: Art and Anti-Art*, Richter writes how the Dadas delighted in torturing the public with false news stories. He describes one newspaper story where the Dadas claimed to have had a pistol duel with a popular poet the Dadas did not like or respect. Of course, this duel had never really happened and was meant to provoke the poet. When the poet angrily wrote in disclaiming this story, the Dadas promptly published a disclaimer of his disclaimer, stating that *of course* the poet didn't want to be associated with their quarrels and, not that it mattered, but they had fired *away* from each other.

So what was Dada's TONE, MOOD, and SPIRIT?

It's hard to talk about any flavor of Dada without mentioning geography. While Dada was an international movement, its most well-known adherents were concentrated in Zurich, Berlin, New York, and, later, Paris.

Zurich seemed too passive for some Dadas, many of whom eventually wound up in Berlin where the movement had reached a pitch because of inflamed sentiments about the war as well as the continuing political upheaval. Paris was initially a center of attraction for the Dadas, but many say that's where Dada eventually died. And New York bred its own version of Dada.

{17

You already met the main cast of characters in Zurich. Who were the main players in Berlin, Paris, and New York?

BERLIN DADA

Berlin Dada was the angriest of the Dada movements—small wonder, though, considering that life in Berlin was defined by rampant inflation, a destabilized government, and revolutionary movements.

CAST OF MAIN CHARACTERS

RICHARD HUELSENBECK, who returned to Berlin from relatively peaceful Zurich, wrote:

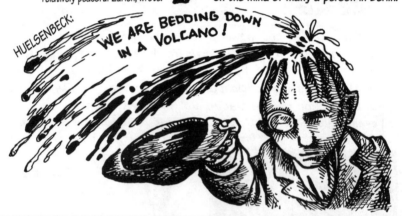

THE SITUATION, WHICH HADN'T BEEN VERY GOOD WHEN I LEFT THE CITY 1916, HAD TURNED TRAGIC ...MANY OF MY FRIENDS HAD BEEN KILLED IN ACTION, THE DESPERATE PROBLEM OF FOOD OCCUPIED EVERYONE THEORETICALLY AND PRACTICALLY. WHAT WOULD BECOME OF GERMANY? AND I SAID OF MYSELF, " WHAT WOULD BECOME OF MAN?"

A question that was likely on the mind of many a person in Berlin.

HUELSENBECK: WE ARE BEDDING DOWN IN A VOLCANO!

With the end of WWI came new struggles with new regimes, new controversies, and new concerns with the weak Weimar Republic. American Matthew Josephson, who participated in many Dada events, wrote: "The German Dadas, in contrast with those of France, had been highly 'political' and acted in sympathy with the Spartacist and Communist insurrectionists of 1919".

The Berlin Dadas included: RICHARD HUELSENBECK, our friend from Zurich, returned to spread Dada to Berlin. He eventually became a doctor and left Germany.

RAOUL HAUSMANN,
"the other 'RH.'"

RICHTER: [Hausmann's] versatility was inexhaustible. ... On one day he was a photomonteur, on the next a painter, on the third a pamphleteer, on the fourth a fashion designer....

ART CRITIC:

THIS IS NOT FLATTERING — HAUSMANN'S MAKING FUN OF ME! WITHOUT PEOPLE LIKE ME, HOW WILL WE KEEP THESE NEW MOVEMENTS IN PROPER PERSPECTIVE SO THE WORLD KNOWS WHAT TO LIKE AND DISLIKE?

HE DESERVES IT!

JOHANNES BAADER,
who called himself
the "OberDada"
or "SuperDada"
(and whose sanity
is still a matter of
contention).

GEORGE GROSZ, {19
another veteran
and a caricatur-
ist who, writes
Josephson, was
well known for his
drawings "of the
famished stand-
ing before...shop
windows filled with
hams, sausages,
cheese, and wine,
while policemen
came to drive
them away with
clubs".

I AM ABLE TO USE PICTURES — COLLAGES, FOR EXAMPLE — TO OFFER SATIRICAL AND SARCASTIC COMMENTARY WITHOUT IT BEING SO OBVIOUS THAT I GET ARRESTED.

OH? WE HATE THIS GUY, WE WILL HAVE TO SEARCH HIS APARTMENT...

EVENTUALLY I FLED TO AMERICA.

As did John Heartfield, Hannah Hoch, and many more.

JOHN HEARTFIELD

NOT SO TIGHT!

ALTHOUGH MANY OF US ENDORSED THE EARLY FORMS OF COMMUNISM, WE WERE ALSO FASCINATED WITH THE UNITED STATES. I CHANGED MY NAME FROM HELMUT HERZFELD TO JOHN HEARTFIED, WHICH WAS MORE ANGLICIZED AND BY EXTENSION MORE AMERICAN, AS A PROTEST AGAINST THE WAR.

PARIS DADA →
CAST OF CHARACTERS

I FIRST USED THE WORD "SURREALIST," NOT ANDRE BRETON.

Dada came to Paris later. The Paris Dadas emerged from a different tradition than the Zurich or Berlin Dadas. They were interested in the French Symbolists and writers such as Guillaume Apollinaire and Stéphane Mallarme. (It is little wonder that it was this group that eventually broke away to become Surrealists.)

The Paris Dadas were aware of the goings-on in Zurich and were curious about events there. In Paris, the Dadas were:

ANDRÉ BRETON, who began as a Dada, but gradually drifted to Surrealism and became a major figure within that movement. His medical training led him to experiments with the subconscious that later influenced the Surrealist artists.

PHILIPPE SOUPAULT, poet, novelist, and essayist who also had medical training, followed Breton into Surrealism but gradually drifted away from Breton's group.

LOUIS ARAGON, poet, novelist, and essayist who, like the others, had some medical training, and whose later departure from the Surrealist movement became known as "The Aragon Affair."

NEW YORK DADA

CAST OF MAIN CHARACTERS

New York Dada didn't call itself Dada at first, even though this version of Dada started as early as the Zurich Dadas. Some of the members of the New York group returned to Europe to see what their contemporaries were up to. Even then, some New York Dadas did not want to be called Dadas.

The New York Dadas, along with many other artists, comprised what came to be known as the "Arensberg Circle." This group met at the apartment of patrons/collectors, the Arensbergs.

The New York Dadas are:

ALFRED STIEGLITZ:

Founder of the 291 Gallery, where many of the New York Dadas exhibited their work, as well as founder of 291 and editor of *Camera Work*, two influential little magazines.

MARCEL DUCHAMP: A Frenchmen who arrived in New York in 1915. He declared that he came to New York because he didn't have anyone to talk to. He greatly admires New York architecture, especially the skyscrapers.

I BELIEVE YOUR IDEA OF DEMOLISHING OLD BUILDINGS, OLD SOUVENIRS IS FINE.

Duchamp emerges as one of the better-known Dada artists.

FRANCIS PICABIA: Although he traveled between the U.S. and Europe and was simultaneously influenced by and communicating with multiple artists of the time, he exhibited his paintings in the United States and collaborated with Duchamp. He founded *391*, the successor to Stieglitz's magazine.

> VEGETABLES ARE MORE SERIOUS THAN MAN, AND MORE SENSITIVE TO FROST.

MAN RAY: Invented his name (his real name was Emanuel Rabinovitch). One of the few Americans to play a part in the Dada movement, Man Ray is best known for his influential photography; particularly his "rayographs," objects placed over photographic paper and exposed to light, leaving intriguing images of light and shadow.

{23

> DADA CANNOT LIVE IN NEW YORK. ALL NEW YORK IS DADA, AND WILL NOT TOLERATE A RIVAL.

And a comparatively minor-but-too-interesting-to-avoid-mentioning character:

ARTHUR CRAVAN:
An American who boasted that he was the nephew of Oscar Wilde, yet had never met him face to face. He also claimed to be a boxer and went so far as to challenge the world champion to a fight and was knocked out in the first round. It's said that one highlight of New York Dada was when Cravan read his poems to an audience while naked.

So now, what did all these Dadas do (and where)?

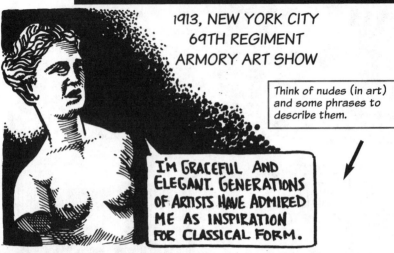

**1913, NEW YORK CITY
69TH REGIMENT
ARMORY ART SHOW**

Think of nudes (in art) and some phrases to describe them.

I'M GRACEFUL AND ELEGANT. GENERATIONS OF ARTISTS HAVE ADMIRED ME AS INSPIRATION FOR CLASSICAL FORM.

So what does a Dada nude look like?

The French artist Marcel Duchamp painted *Nude Descending a Staircase* and exhibited it at this show.

WHY IS VENUS'S AESTHETIC REGARDED AS SO RELENTLESSLY SUPERIOR? WE HAVE SEEN HER SO MANY TIMES—ARE WE EVER GIVING HER MORE THAN A PASSING GLANCE ANY MORE? DUCHAMP ENSURED I'D PROVOKE PEOPLE TO *LOOK* AGAIN.

IT'S AN EXPLOSION IN A SHINGLE FACTORY!

OR IS THIS THAT NEW CUBIST STUFF?

I JUST DON'T LIKE IT.

THE AMERICAN PUBLIC WAS SHOCKED!

So what kinds of shows were the Dadas performing at the Cabaret Voltaire? The shows started off with poetry readings and musical performances of a more traditional bend, but they began to change....

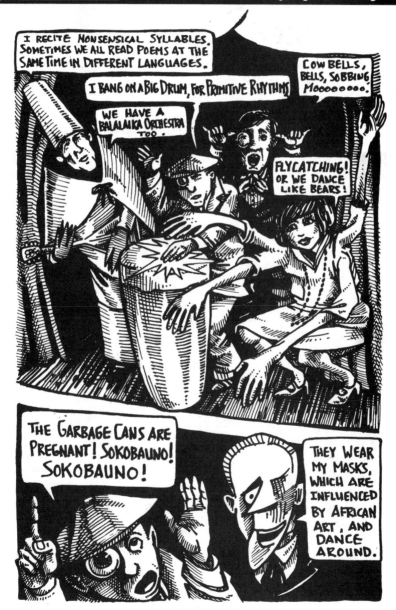

{25

ALAS, OUR GOOD KASPAR IS DEAD.
WHO WILL CONCEAL THE
BURNING BANNER IN THE CLOUD'S
PIGTAIL NOW AND BLACKLY
THUMB HIS DAILY NOSE
WHO WILL RUN THE COFFEE GRINDER
IN THE PRIMEVAL CASK NOW
WHO WILL ENTICE THE IDYLLIC DEER
OUT OF THE PETRIFIED BAG
WHO WILL BLOW THE NOSES OF
SHIPS UMBRELLAS BEEKEEPERS
OZONE-SPINDLES AND
BONE PYRAMIDS
ALAS ALAS ALAS OUR GOOD KASPAR
IS DEAD. GOODNESS
GRACIOUS ME
KASPAR IS DEAD.

26}

I DON'T GET. WHAT DOES IT MEAN? ISN'T IT SUPPOSED TO MEAN SOMETHING?

I DON'T GET IT, BUT I DON'T MIND THAT I DON'T GET IT — MAYBE I DON'T HAVE TO "GET IT."

The Dadas were forced to abandon the Cabaret Voltaire about a year after it opened and started a second gallery called Galerie Dada. Their ideas spread throughout Europe, particularly through a little magazine called *Dada*, edited by Tzara, who emerged as the leader of Dada. While the idea of having a "leader" seems contradictory to the spirit of Dada, it was—yet the Dadas had few problems with contradictions.

Meanwhile in Paris and around the world, other artists were beginning to take note of the little magazine.

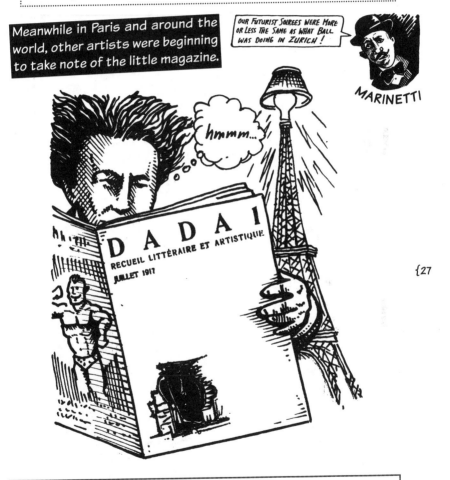

OUR FUTURIST SOIREES WERE MORE OR LESS THE SAME AS WHAT BALL WAS DOING IN ZURICH!

MARINETTI

hmmm...

DADA I
RECUEIL LITTÉRAIRE ET ARTISTIQUE
JUILLET 1917

The word "Dada" is also supposedly invented, or chosen this year. The Dadas bitterly disputed who came up with the word, when, and how. Perhaps it shouldn't have mattered to them, yet it remained a controversy.

and back over in Berlin....

1917, BERLIN
THE REPUBLIC AND "CHURCH OF DADA"?

Johannes Baader is not one of today's better-known Dadas, but nonetheless he made some statements that were admired among Dadas and that perhaps show Dada in a way the other artists' statements don't.

I NOMINATED MYSELF AS PRESIDENT OF THE DADA REPUBLIC, MOCKED POLITICIANS, AND DECLARED, "WE SHALL BLOW THE WEIMAR SKY-HIGH."

UH... AS I POINT OUT IN MY BOOK, *THAT* CERTAINLY ATTRACTED NATIONAL ATTENTION.

Baader later went on to disturb church services with declarations against the church. (Accounts on what he actually said vary, but it wasn't very nice.)

IN CHURCH! SPEAK AGAINST THE CHURCH? OH, HEAVENLY STARS!

Even though Baader cast himself as Dada president, Richter describes Baader as "removed from normality" and "in a permanent state of euphoria." Richter wasn't the only Dada to note Baader's peculiarities, which seemed to stretch beyond those of the rest of the group.

The Dadas admired the unconventionality of the mad, and didn't seem to disturb themselves too much with the question of whether Baader maybe actually was mad.

WELL, WE COULD ARREST HIM, SPEAKING OUT AS HE DOES, BUT REALLY, WE BELIEVE HE IS JUST CRAZY. *OR IS HE...?*

Duchamp was dabbling in Dada early. Known for his "ready-mades," he selected random objects and simply placed them together in ways he found aesthetically pleasing. Perhaps his best known "ready-made" is a bicycle wheel attached to a stool, called simply *Bicycle Wheel*.

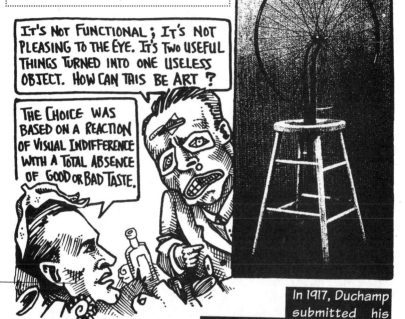

IT'S NOT FUNCTIONAL; IT'S NOT PLEASING TO THE EYE. IT'S TWO USEFUL THINGS TURNED INTO ONE USELESS OBJECT. HOW CAN THIS BE ART?

THE CHOICE WAS BASED ON A REACTION OF VISUAL INDIFFERENCE WITH A TOTAL ABSENCE OF GOOD OR BAD TASTE.

{29

In 1917, Duchamp submitted his piece *La Fontaine* to an exhibition. Any paying artist was supposed to be able to exhibit. But a urinal? As art? That was Duchamp's idea. Turn it upside down. And sign it with the fake name of R. Mutt.

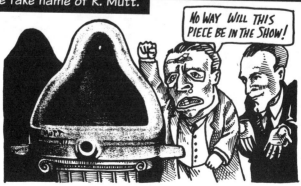

NO WAY WILL THIS PIECE BE IN THE SHOW!

A fellow Dada named Beatrice Wood defended the work:

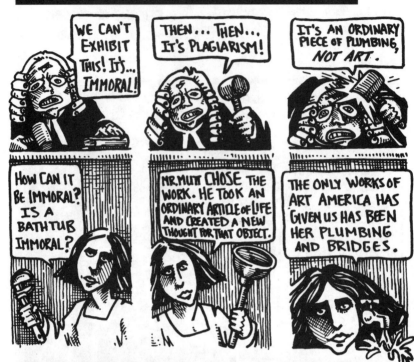

Duchamp was making a bold statement: Art didn't have to come from the academy or be part of an academic study, it didn't have to be "pretty," and it did not have to represent anything. The artist's eye, choosing something, made it art.

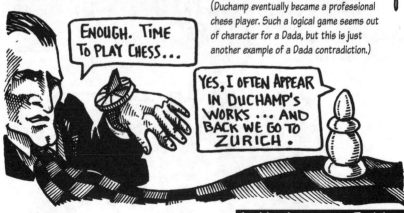

(Duchamp eventually became a professional chess player. Such a logical game seems out of character for a Dada, but this is just another example of a Dada contradiction.)

And back we go to Zurich....

1918, ZURICH
TZARA'S DADA MANIFESTO

Well, we've heard about these Dadas. What do they stand for?

Anyone asking that question will be further perplexed by Tristan Tzara's manifesto. The tone is one of great anger and frustration, as Tzara lashes out at everything and nothing:

I AM WRITING A MANIFESTO AND THERE IS NOTHING I WANT, AND YET I'M SAYING CERTAIN THINGS, AND IN PRINCIPLE I AM AGAINST PRINCIPLES... I'M WRITING THIS MANIFESTO TO SHOW THAT YOU CAN PERFORM CONTRARY ACTIONS AT THE SAME TIME, IN ONE SINGLE, FRESH BREATH; I AM AGAINST ACTION; AS FOR CONTINUAL CONTRADICTION AND AFFIRMATION TOO, I AM NEITHER FOR NOR AGAINST THEM, AND I WON'T EXPLAIN MYSELF BECAUSE I HATE COMMON SENSE... *DADA DOES NOT MEAN ANYTHING.*

{31

HE DOESN'T SEEM TO STAND FOR ANYTHING... IS THAT EVEN POSSIBLE?

EVERY MAN MUST SHOUT: THERE IS GREAT DESTRUCTIVE, NEGATIVE WORK TO BE DONE TO SWEEP, TO CLEAN. THE CLEANLINESS OF THE INDIVIDUAL MATERIALISES AFTER WE'VE GONE THROUGH FOLLY, THE AGGRESSIVE, COMPLETE FOLLY OF A WORLD LEFT IN THE HANDS OF BANDITS WHO HAVE DEMOLISHED AND DESTROYED THE CENTURIES.

SOUNDS SO... DESTRUCTIVE, BUT THESE WARS, MAYBE IT'S TIME FOR SOMETHING NEW IN ART. BUT... THE DADAS DIDN'T SEEM TO PROPOSE ANYTHING NEW

I WROTE A DADA MANIFESTO, TOO, IN 1916.

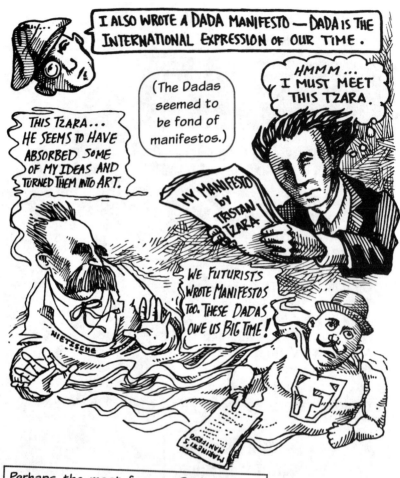

(The Dadas seemed to be fond of manifestos.)

32}

Perhaps the most famous Dada work is Marcel Duchamp's replica of the Mona Lisa with an added moustache called *LHOOQ*.

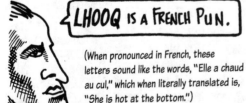

(When pronounced in French, these letters sound like the words, "Elle a chaud au cul," which when literally translated is, "She is hot at the bottom.")

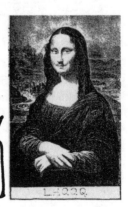

A small group of temporary Dadas emerges in Paris: Louis Aragon, Philippe Soupault, and André Breton. *Litterature* was a small magazine edited by Aragon and Breton, with a sarcastically dull and pompous title. *Litterature* was the way that Breton gradually overtook the Dada movement, using it as his main vehicle for publication.

1920, BERLIN
FIRST
INTERNATIONAL
DADA FAIR

Political upheaval helped make Berlin Dada particularly controversial and uproarious. The Berlin Dadas joined together to viciously protest Authority in its many guises.

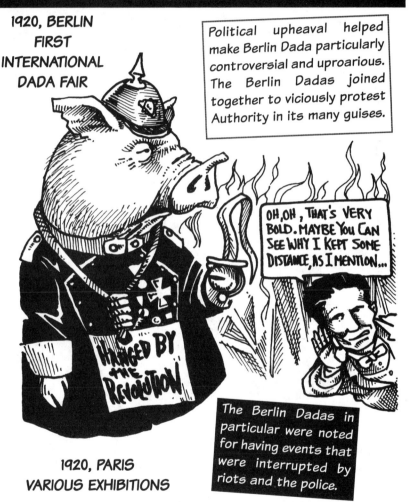

OH, OH, THAT'S VERY BOLD. MAYBE YOU CAN SEE WHY I KEPT SOME DISTANCE, AS I MENTION...

{33

HANGED BY the REVOLUTION

The Berlin Dadas in particular were noted for having events that were interrupted by riots and the police.

1920, PARIS
VARIOUS EXHIBITIONS

At the Dada exhibitions in Paris, the theater-going audience was lured in under various pretenses (such as promising the appearance of Charlie Chaplin or the Dadas shaving their heads on stage) and then subjected to direct insults like Picabia's *Manifeste Cannibale*:

WHAT ARE YOU ALL DOING OUT THERE SITTING ABOUT LIKE DUMB CLUCKS—FOR YOU ARE SERIOUS, AREN'T YOU? DEATH IS A SERIOUS THING, ISN'T IT?...YOU LIKE DEATH FOR OTHER PEOPLE BUT NOT FOR YOURSELVES. THERE IS ONLY MONEY THAT DOES NOT DIE BUT JUST TRAVELS AROUND. IT IS THE ONLY GOD YOU WORSHIP.

The more the newspapers reported on the Dada performances, the more audiences seemed to attend. But as the audiences caught on to the Dada's antics, they began to bring vegetables and steaks with which they pelted the Dadas.

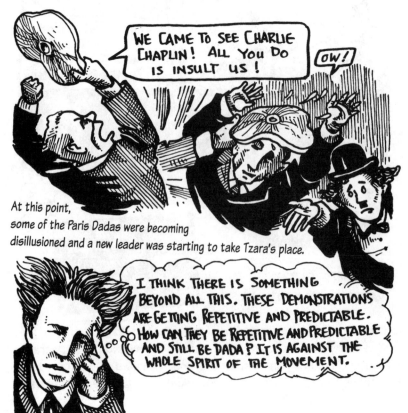

WE CAME TO SEE CHARLIE CHAPLIN! ALL YOU DO IS INSULT US!

OW!

34}

At this point, some of the Paris Dadas were becoming disillusioned and a new leader was starting to take Tzara's place.

I THINK THERE IS SOMETHING BEYOND ALL THIS. THESE DEMONSTRATIONS ARE GETTING REPETITIVE AND PREDICTABLE. HOW CAN THEY BE REPETITIVE AND PREDICTABLE AND STILL BE DADA? IT IS AGAINST THE WHOLE SPIRIT OF THE MOVEMENT.

1921, PARIS — DADA CRACKS

By 1921, the infighting among Dadas had become intense.

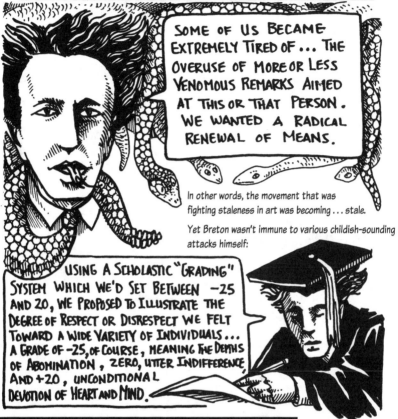

SOME OF US BECAME EXTREMELY TIRED OF ... THE OVERUSE OF MORE OR LESS VENOMOUS REMARKS AIMED AT THIS OR THAT PERSON. WE WANTED A RADICAL RENEWAL OF MEANS.

In other words, the movement that was fighting staleness in art was becoming ... stale.

Yet Breton wasn't immune to various childish-sounding attacks himself:

USING A SCHOLASTIC "GRADING" SYSTEM WHICH WE'D SET BETWEEN −25 AND 20, WE PROPOSED TO ILLUSTRATE THE DEGREE OF RESPECT OR DISRESPECT WE FELT TOWARD A WIDE VARIETY OF INDIVIDUALS ... A GRADE OF −25, OF COURSE, MEANING THE DEPTHS OF ABOMINATION, ZERO, UTTER INDIFFERENCE AND +20, UNCONDITIONAL DEVOTION OF HEART AND MIND.

Breton's group also chose various historical and contemporary figures and rated how *they* would see the Dadas. (Tzara seldom scored well with anyone.)

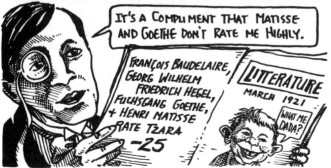

IT'S A COMPLIMENT THAT MATISSE AND GOETHE DON'T RATE ME HIGHLY.

FRANÇOIS BAUDELAIRE, GEORG WILHELM FRIEDRICH HEGEL, FUCHSGANG GOETHE, + HENRI MATISSE RATE TZARA −25

LITTERATURE MARCH 1921

WHAT ME DADA?

Tzara responded with his own attacks. But Dada was failing to hold the interest of many of the original artists as well as the public. Duchamp refused to attend some Dada events and Picabia lost interest as well.

Gradually, Breton took over the publication of *Litterature*, and stopped associating with all things Dada.

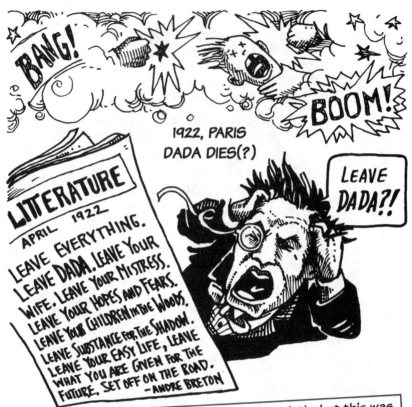

BANG!

BOOM!

1922, PARIS
DADA DIES(?)

LITTERATURE
APRIL 1922

LEAVE EVERYTHING. LEAVE DADA. LEAVE YOUR WIFE. LEAVE YOUR MISTRESS. LEAVE YOUR HOPES AND FEARS. LEAVE YOUR CHILDREN IN THE WOODS. LEAVE SUBSTANCE FOR THE SHADOW. LEAVE YOUR EASY LIFE, LEAVE WHAT YOU ARE GIVEN FOR THE FUTURE. SET OFF ON THE ROAD.
—ANDRE BRETON

LEAVE DADA?!

The artists might have gone their own ways quietly, but this was, after all, a bunch of Dadas, and naturally, there needed to be something climactic to represent this split. And so there was.

The account, which both Richter and Josephson provide, goes something like this: Breton and his cohorts showed up to jeer at a play of Tzara's. They jumped on the stage, and, according to Josephson, Breton broke someone's arm, Tzara leapt on Breton, and poet Paul Eluard was thrown into the footlights. The next day Eluard was sued for eight thousand francs!

PAUL ELUARD

WHAT DID I GET MYSELF INTO?

CRACK!

While this episode may not be seen as the "end" of Dada, the split between factions was widened, and many artists previously associated with the movement began to associate themselves with Breton's surrealism.

A less-known Dada, Franz Jung, got some attention with a bold political action in the name of art.

HERE YA GO, COMRADE.

UH...THANKS.

By this point, Dada had lost much of its momentum, but there were still a few Dada events from time to time.

{37

RICHTER:

He hijacked a German freighter and forced the captain to set his course for Petrograd. There he presented ship and cargo to the Soviet authorities. . .

They did not accept the gift.

Jung, like many of the Dadas, abandoned the movement and engaged in more overt political activity, a direction that many Dadas took.

Kurt Schwitters, who is now regarded as a Dada, was never really accepted by the rest of the Dadas. He attempted to join the Berlin Dadas but was rejected. Perhaps in a sense, he was more Dada than any of the others.

I COULD NOT BEAR HIS BOURGEOIS FACE.

I SHALL VISIT THE DADA CARICATURIST GEORG GROSZ. SURELY HE WILL BE GLAD TO MEET ME.

GOOD MORNING, HERR GROSZ. MY NAME IS SCHWITTERS.

I AM NOT GROSZ.

JUST A MINUTE.

SLAM!

I AM NOT SCHWITTERS, EITHER.

ACTUALLY, SCHWITTERS WAS A DEDICATED ARTIST, AND MANY DADAS DIDN'T LIKE THAT.

Schwitters, unperturbed, still befriended some of the other Dadas.

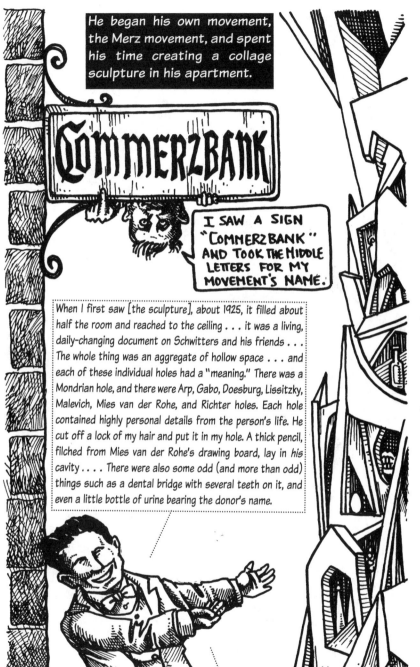

He began his own movement, the Merz movement, and spent his time creating a collage sculpture in his apartment.

Commerzbank

I SAW A SIGN "COMMERZBANK" AND TOOK THE MIDDLE LETTERS FOR MY MOVEMENT'S NAME.

When I first saw [the sculpture], about 1925, it filled about half the room and reached to the ceiling . . . it was a living, daily-changing document on Schwitters and his friends . . . The whole thing was an aggregate of hollow space . . . and each of these individual holes had a "meaning." There was a Mondrian hole, and there were Arp, Gabo, Doesburg, Lissitzky, Malevich, Mies van der Rohe, and Richter holes. Each hole contained highly personal details from the person's life. He cut off a lock of my hair and put it in my hole. A thick pencil, filched from Mies van der Rohe's drawing board, lay in *his* cavity There were also some odd (and more than odd) things such as a dental bridge with several teeth on it, and even a little bottle of urine bearing the donor's name.

When I visited him again three years later, the column was totally different...covered by other sculptural excrescences, new people, new shapes, colours and details.

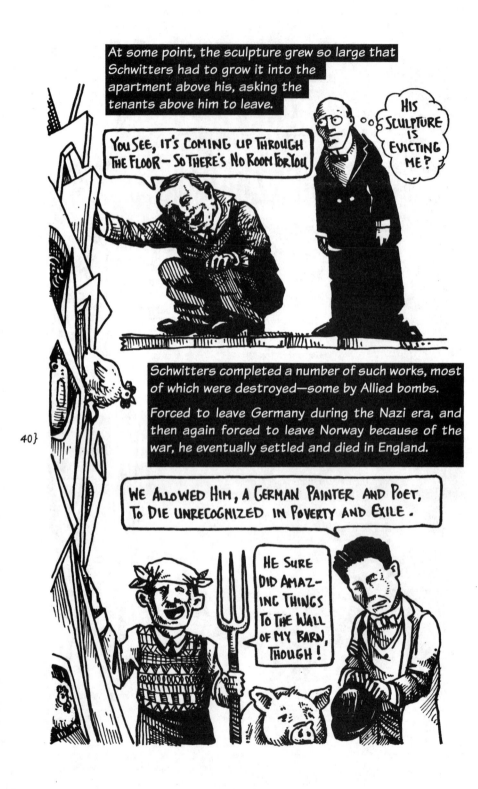

At some point, the sculpture grew so large that Schwitters had to grow it into the apartment above his, asking the tenants above him to leave.

YOU SEE, IT'S COMING UP THROUGH THE FLOOR—SO THERE'S NO ROOM FOR YOU

HIS SCULPTURE IS EVICTING ME?

40}

Schwitters completed a number of such works, most of which were destroyed—some by Allied bombs.

Forced to leave Germany during the Nazi era, and then again forced to leave Norway because of the war, he eventually settled and died in England.

WE ALLOWED HIM, A GERMAN PAINTER AND POET, TO DIE UNRECOGNIZED IN POVERTY AND EXILE.

HE SURE DID AMAZING THINGS TO THE WALL OF MY BARN, THOUGH!

Given Tzara's own statement "The true Dadas are separate from Dada" as well as the irony of the destruction of Schwitter's art, perhaps he could indeed be considered a Dada in the most honorable (or dishonorable) sense of the word.

NOT DADA, NOT DADA — MERZ! I AM MERZ!

And that brings us to this question...

WHAT MAKES ART DADA?

CHAPTER THREE
THE SUN, THE EGG, AND 391 ATTITUDES

391

DADA HAS 391 DIFFERENT ATTITUDES AND COLOURS ACCORDING TO THE SEX OF THE PRESIDENT. IT CHANGES—AFFIRMS—SAYS THE OPPOSITE AT THE SAME TIME—NO IMPORTANCE—SHOUTS—GOES FISHING.

DADA IS THE SUN, DADA IS THE EGG. DADA IS THE POLICE OF THE POLICE.

So now let's consider some characteristics of Dada art. You are now entering the Gallery of Dada, and we have to ask: What makes a work "Dada?" What are some of those 391 attitudes?

{43

ARE YOU REALLY GOING TO TALK TO THEM ABOUT THAT? IT IS SUCH A BOURGEOIS QUESTION! YOU ARE NOT DADA! WE DENOUNCE YOU!

Well, we already explained why this book is not Dada. And perhaps now, in today's time and place, Dada needs to be approached differently, with some consideration for the times during which it was created.

I REALLY THINK YOU'D BE BETTER OFF RUNNING INTO THE STREETS AND CRYING OUT DADADADADA! BUT I WILL ADD SOME COMMENTARY FOR YOU PEOPLE FROM THE FUTURE.

So...why is it obvious sometimes when something is a Dada piece? What is it that we're supposed to "expect" from Dada art? If there are 391 attitudes of Dada, there must be some common characteristics.

But perhaps it is worthwhile first to extend a caution about artistic movements here. It's important not to pigeonhole artists to the point where their individual art and expression is overshadowed by a "movement" or popular generalization about that movement. Each Dada artist is still distinct.

LET'S SEE, IT IS DADA IF IT FITS THESE CRITERIA...

'DADA CHECKLIST'!

NO! NO! PELT HIM WITH A STEAK!

HELP!

SIMULTANEITY, CONTRADICTION, AND PARADOX

The Dadas delighted in contradiction and paradox. They were not frightened by the idea that different, often contrary things could be simultaneously true or equally valid.

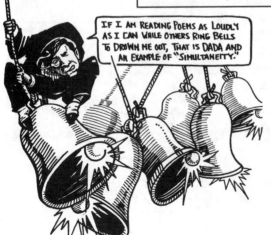

IF I AM READING POEMS AS LOUDLY AS I CAN WHILE OTHERS RING BELLS TO DROWN ME OUT, THAT IS DADA AND AN EXAMPLE OF "SIMULTANEITY."

Nor were they concerned if things didn't have rankings or hierarchies. For example, they enjoyed performances that refused to give center stage to any single performer.

We might also consider that Dada crossed geographical and artistic boundaries, and that the Dada artists were polymathic in their pursuits. The Dadas might be poets, painters, dancers, sculptors, actors, filmmakers, and musicians, too. By taking down barriers between various art forms, the Dadas were able to invent new techniques.

SPONTANEITY, IRRATIONALITY, RANDOMNESS!

How does one go about making a Dada poem? One certainly can't think too much about a Dada poem, nor can the poem have common sense or logic.

TAKE A NEWSPAPER.
TAKE A PAIR OF SCISSORS.
CHOOSE AN ARTICLE AS LONG AS YOU ARE PLANNING TO MAKE YOUR POEM.
CUT OUT THE ARTICLE.
THEN CUT OUT EACH OF THE WORDS THAT MAKE UP THIS ARTICLE AND PUT THEM IN A BAG.
SHAKE IT GENTLY.
THEN TAKE OUT THE SCRAPS ONE AFTER THE OTHER IN THE ORDER IN WHICH THEY LEFT THE BAG.
COPY CONSCIENTIOUSLY.
THE POEM WILL BE LIKE YOU.
AND HERE YOU ARE A WRITER, INFINITELY ORIGINAL AND ENDOWED WITH A SENSIBILITY THAT IS CHARMING THOUGH BEYOND THE UNDERSTANDING OF THE VULGAR.

AND HERE IS AN EXAMPLE :

WHEN THE DOGS CROSS THE AIR IN A DIAMOND LIKE THE IDEAS AND THE APPENDIX OF MENINGES SHOWS THE HOUR OF AWAKENING PROGRAM.

WE DO NOT FEEL BOUND BY THE "RULES" OF TYPOGRAPHY, EITHER. MANY OF OUR MAGAZINES EXPERIMENTED WITH TYPE.

UH... BUT WHAT DOES IT *MEAN*?

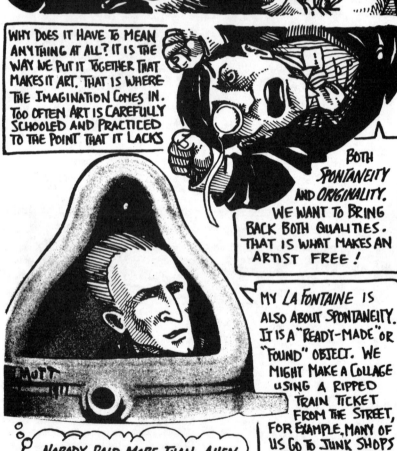

WHY DOES IT HAVE TO MEAN ANYTHING AT ALL? IT IS THE WAY WE PUT IT TOGETHER THAT MAKES IT ART. THAT IS WHERE THE IMAGINATION COMES IN. TOO OFTEN ART IS CAREFULLY SCHOOLED AND PRACTICED TO THE POINT THAT IT LACKS

BOTH *SPONTANEITY* AND *ORIGINALITY*. WE WANT TO BRING BACK BOTH QUALITIES. THAT IS WHAT MAKES AN ARTIST FREE!

MY *LA FONTAINE* IS ALSO ABOUT SPONTANEITY. IT IS A "READY-MADE" OR "FOUND" OBJECT. WE MIGHT MAKE A COLLAGE USING A RIPPED TRAIN TICKET FROM THE STREET, FOR EXAMPLE. MANY OF US GO TO JUNK SHOPS TO "FIND" ART. IT'S OKAY TO "DISCOVER" ART RATHER THAN CREATE IT.

NOBODY PAID MORE THAN, AHEM, UTILITARIAN ATTENTION TO ME UNTIL DUCHAMP TURNED ME UPSIDE DOWN AND MADE ME FAMOUS.

DESTRUCTIVE FORCE: AN ANGRY "SWEEPING" OF THE OLD

The Dadas were not interested in the past generations of art and saw no need to preserve and protect it. Rather, they wanted to sweep out the "old" art and destroy it.

Some also wanted to prevent their own work from being preserved and thus from becoming too accepted and part of the very world they rejected. As we mentioned, there is a nihilistic quality to that kind of destruction, but the Dadas also saw it as a "cleansing." (And after all, art is not supposed to be a continual parroting and mimicking of previous genera-tions—the Dada's legacy was to legitimize and rep-resent their own time, place, and future.)

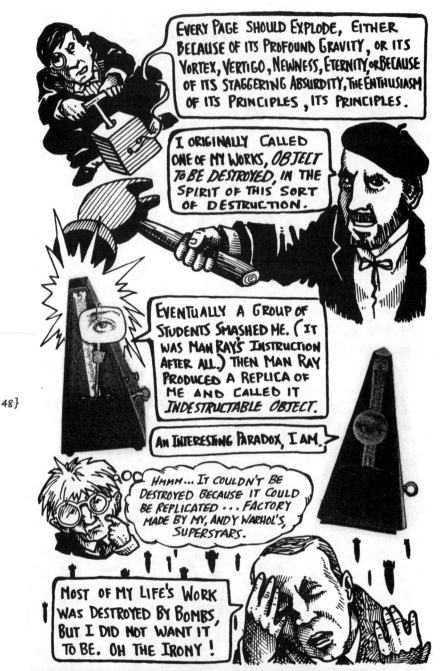

EVERY PAGE SHOULD EXPLODE, EITHER BECAUSE OF ITS PROFOUND GRAVITY, OR ITS VORTEX, VERTIGO, NEWNESS, ETERNITY, OR BECAUSE OF ITS STAGGERING ABSURDITY, THE ENTHUSIASM OF ITS PRINCIPLES, ITS PRINCIPLES.

I ORIGINALLY CALLED ONE OF MY WORKS, *OBJECT TO BE DESTROYED*, IN THE SPIRIT OF THIS SORT OF DESTRUCTION.

EVENTUALLY A GROUP OF STUDENTS SMASHED ME. (IT WAS MAN RAY'S INSTRUCTION AFTER ALL.) THEN MAN RAY PRODUCED A REPLICA OF ME AND CALLED IT *INDESTRUCTABLE OBJECT*.

AN INTERESTING PARADOX, I AM.

HMMM... IT COULDN'T BE DESTROYED BECAUSE IT COULD BE REPLICATED... FACTORY MADE BY MY, ANDY WARHOL'S, SUPERSTARS.

MOST OF MY LIFE'S WORK WAS DESTROYED BY BOMBS, BUT I DID NOT WANT IT TO BE. OH THE IRONY!

Some Dadas carried this "sweeping" nihilism to extremes. Several committed suicide and even saw it as a Dada act.

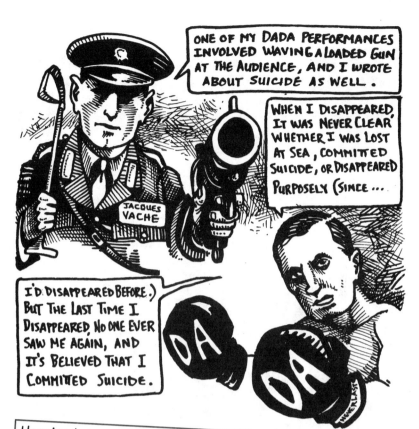

Here is where we must keep in mind, the despair that many of the Dadas felt because of the war and the frustrations they had in what they saw as the previous generations' betrayal of humanity, it must have been exceedingly difficult to feel any sense of optimism about the future. Considering the historical events that these artists were seeing and living, is it any wonder that the art is ugly (albeit in a kind of vital way)?

And should have these artists been forced to depict landscapes that had already been seen? The Dadas chose to depict their disjointed views of the world that they were seeing instead—politics and whole systems of thought that were crumbling at the time.

Yet another side to Dada is that it insisted on freedom for human beings to create, to be expressive, to believe, and to love.

Although many of the Dadas were themselves from middle-class families, they were fervently against many of the values of the middle class. They saw those values as hypocritical, creating the climate for the war, fueling acceptance for it, and restricting the freedoms of human beings to think and love with a seemingly endless series of random moral rules.

50}

Sometimes these attacks resulted in ugly art. If art was ugly, then theoretically it wouldn't appeal to the bourgeois values of beauty (and the bourgeois would just try to match the painting to the sofa anyway, so to speak). It also reflected the ugliness that surrounded the Dadas, especially the Berlin Dadas, in their daily lives.

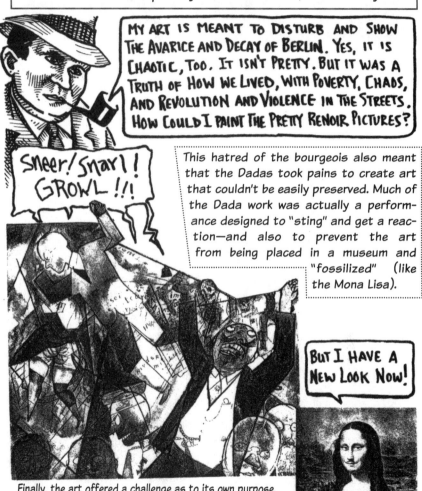

MY ART IS MEANT TO DISTURB AND SHOW THE AVARICE AND DECAY OF BERLIN. YES, IT IS CHAOTIC, TOO. IT ISN'T PRETTY. BUT IT WAS A TRUTH OF HOW WE LIVED, WITH POVERTY, CHAOS, AND REVOLUTION AND VIOLENCE IN THE STREETS. HOW COULD I PAINT THE PRETTY RENOIR PICTURES?

Sneer! Snarl!! GROWL!!!

This hatred of the bourgeois also meant that the Dadas took pains to create art that couldn't be easily preserved. Much of the Dada work was actually a performance designed to "sting" and get a reaction—and also to prevent the art from being placed in a museum and "fossilized" (like the Mona Lisa).

{51

BUT I HAVE A NEW LOOK NOW!

Finally, the art offered a challenge as to its own purpose.

DO WE MAKE ART IN ORDER TO EARN MONEY AND KEEP THE BOURGEOISIE HAPPY?

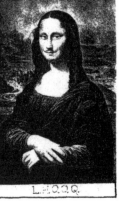

L.H.O.O.Q.

The Dadas wanted art to be free in many senses of the word—a freely made expression in a world that was increasingly intolerant of such aspects of the human spirit, something that was not easy to buy and sell. And they wanted art that defied bourgeois expectations. Art wasn't for collecting and making money—it was for defying expectations and provoking people to action that the Dadas saw as desperately needed.

A CELEBRATION OF "PRIMITIVE" ART

The Dadas were fascinated by art of "primitive" cultures. They saw this art as closer to the imagination and the intuitive—and as less highly stylized and "schooled" than contemporary Western art, which for them made it more spontaneous and thus more "Dada."

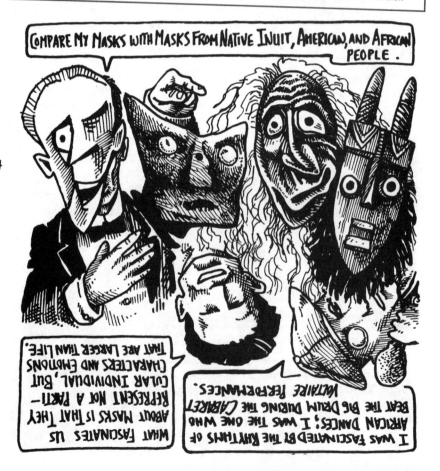

COMPARE MY MASKS WITH MASKS FROM NATIVE INUIT, AMERICAN, AND AFRICAN PEOPLE.

WHAT FASCINATES US ABOUT MASKS IS THAT THEY REPRESENT NOT A PARTICULAR INDIVIDUAL, BUT CHARACTERS AND EMOTIONS THAT ARE LARGER THAN LIFE.

I WAS FASCINATED BY THE RHYTHMS OF AFRICAN DANCES; I WAS THE ONE WHO BEAT THE BIG DRUM DURING THE CABARET VOLTAIRE PERFORMANCES.

PRIMITIVE ART FROM CAVES SHOWS THAT HUMAN BEINGS HAVE, FOR EONS, LEFT HAND IMPRINTS AS A WAY OF SAYING "I'M HERE." WHEN WE SEE ART IN A MUSEUM, THE IDEA IS OFTEN "IT'S PRECIOUS, IT'S SPECIAL—BE POLITE, DON'T TOUCH!"

AN ANTHROPOMORPHISM OF MACHINES

The Dadas were both fascinated and repelled by machines. Machines and technology were taking a forefront in WWI—airplanes, mustard gas, and other such "innovations" revealed their capacity for destruction on an unprecedented scale.

While the Futurists revered machines (and war, for that matter) and brought both to art, the Dadas were more skeptical and willing to mock mechanization. In their realm, machines might have no discernible purposes or might take on human characteristics (representing human body parts, for example). Given a culture that was relying increasingly on machines for nearly every imaginable purpose, was it possible for a machine to be erotic, for example?

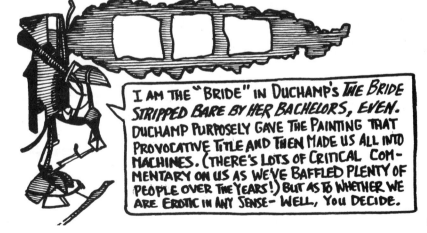

I AM THE "BRIDE" IN DUCHAMP'S *THE BRIDE STRIPPED BARE BY HER BACHELORS, EVEN*. DUCHAMP PURPOSELY GAVE THE PAINTING THAT PROVOCATIVE TITLE AND THEN MADE US ALL INTO MACHINES. (THERE'S LOTS OF CRITICAL COMMENTARY ON US AS WE'VE BAFFLED PLENTY OF PEOPLE OVER THE YEARS!) BUT AS TO WHETHER WE ARE EROTIC IN ANY SENSE—WELL, YOU DECIDE.

PUFF! SNORT! I'M HALF-MACHINE, HALF-CREATURE. I WAS MODELED AFTER A CORN BIN... (SOMETIMES I'M CONSIDERED A DADA PICTURE AND SOMETIMES SURREALIST)

THE QUESTION OF DADA SIGNIFICANCE

So...what are we to think of the Dadas? Has their work lasted? How is it recorded in history?

SIGH. YOU HAVE TO ASK THAT QUESTION?

Context and time frame are critical to empathizing with these artists, as they were a generation torn apart by some of the most horrific warfare the world has ever seen.

Choices for a new world must have seemed bewildering, and perhaps impossible at times: One needs to understand that this was a furious generation that had lost millions of young men, and must have been exceedingly difficult to believe in any power structures or institutions of the times. Perhaps, too, Dada meant that the young people were asserting a *freedom of thought and individual expression* during a time when freedoms seemed severely limited or perhaps even in danger of disappearing altogether.

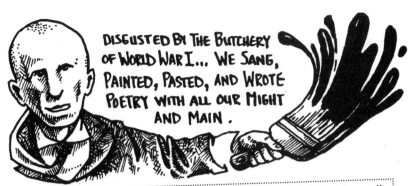

DISGUSTED BY THE BUTCHERY OF WORLD WAR I... WE SANG, PAINTED, PASTED, AND WROTE POETRY WITH ALL OUR MIGHT AND MAIN.

So if you're looking at a Dada piece and think "That's really ugly" or "But anybody could do that," it's important to understand that the Dadas were asserting their RIGHT to freedom of expression and to create art that didn't fit into preconceived ideas of what art SHOULD be.

HMMM. BUT I'M NOT SURE I CAN ADMIRE THESE DADAS. THEY DON'T SEEM TO STAND FOR ANYTHING AND THEY'RE ... *NIHILISTIC.*

Can you admire a movement that claims to stand for nothing?

Or does Dada actually stand for something, anything at all? You can hardly deny that the movement makes some deeply nihilistic statements, but the Dadas were perhaps less nihilistic than paradoxical and contradictory. Dada says it doesn't make sense...

YET WE'VE PAID MORE ATTENTION TO THIS WORK THAN ALL THE TRADITIONAL PIECES AND IT'S PROVOKED MORE REACTION THAN EVERYTHING ELSE PUT TOGETHER...

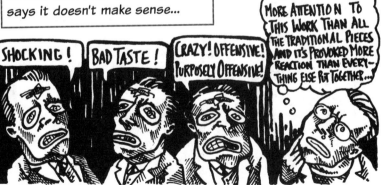

SHOCKING!

BAD TASTE!

CRAZY! OFFENSIVE! PURPOSELY OFFENSIVE!

...and the Dadas don't want it to make sense, and yet it still "makes sense." It still communicates to people and gets a reaction. It still has a message, and a historical logic.

So the Dadas' elusiveness and resistance to definition—to the point where they claimed they did not WANT to be recognized historically—is not the same thing as standing for nothing. They resisted definition and pigeonholes, but art *did* have a purpose for them: it was a way of escaping what they saw as a prevailing clinical, controlling, scientific, rational mindset that dominated their times. In their views, the exclusiveness of such a mindset brought about a lack of IMAGINATION and SPONTANEITY, a rigidity that they hated.

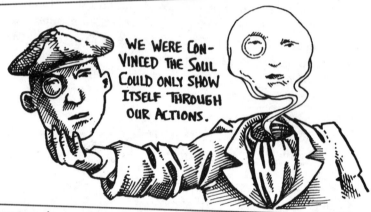

Of course, in a paradoxical twist, the Dadas ARE recognized historically (and are gaining further recognition today), which leads one to consider if their resistance to being historically categorized is *exactly* what makes them historically fascinating (and if, on some level, they knew that would be the case)!

Caught in a world ravaged by war, the Dadas were also willing to challenge the status quo, as they were acutely aware of their society at large and the institutional powers that professed "common sense" and rationality but acted with hypocrisy and without real sense or humanity. The Dadas used art for action— to attempt to undermine power structures that had ravaged Europe. Negative anti-art (art that challenged the status quo or accepted definition of Art) would progress art into the future.

Power structures such as institutions and museums turned art into something dormant—the Dadas demanded an art that was lived and experienced, and an art for everyone, not just the people who could afford it.

YOU SEE, IF LA FONTAINE CAN BE AN ART OBJECT, THAT MAKES IT PART OF THE ARTIST'S IMAGINATION — AND YOU CANNOT TAKE IMAGINATION AWAY FROM INDIVIDUAL HUMAN BEINGS WHO CAN'T AFFORD ART.

{57

One might also consider that many Dadas were extraordinarily brave in the face of powerful political factions well beyond their control (to the point where they feared for their lives). Frequently just skirting censors and authorities, and certainly not beloved by the institutions they attacked, the Dadas developed ingenious techniques for infiltrating various political movements while still remaining aloof from any direct political statement, and thus free (since freedom of human spirit is part of what Dada is "about").

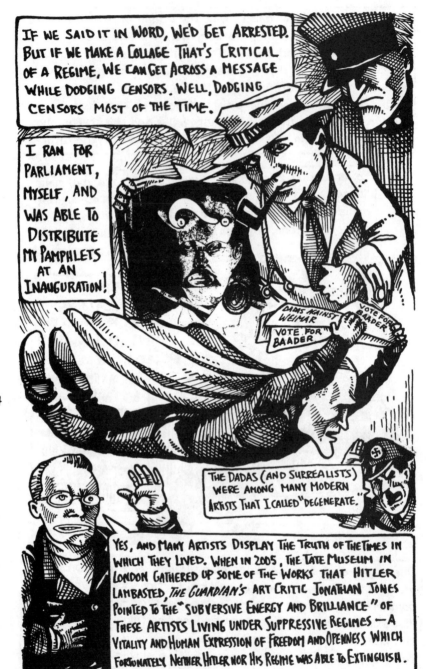

IF WE SAID IT IN WORD, WE'D GET ARRESTED. BUT IF WE MAKE A COLLAGE THAT'S CRITICAL OF A REGIME, WE CAN GET ACROSS A MESSAGE WHILE DODGING CENSORS. WELL, DODGING CENSORS MOST OF THE TIME.

I RAN FOR PARLIAMENT, MYSELF, AND WAS ABLE TO DISTRIBUTE MY PAMPHLETS AT AN INAUGURATION!

DADAS AGAINST WEIMAR

VOTE FOR BAADER

VOTE FOR BAADER

THE DADAS (AND SURREALISTS) WERE AMONG MANY MODERN ARTISTS THAT I CALLED "DEGENERATE."

YES, AND MANY ARTISTS DISPLAY THE TRUTH OF THE TIMES IN WHICH THEY LIVED. WHEN IN 2005, THE TATE MUSEUM IN LONDON GATHERED UP SOME OF THE WORKS THAT HITLER LAMBASTED, *THE GUARDIAN'S* ART CRITIC JONATHAN JONES POINTED TO THE "SUBVERSIVE ENERGY AND BRILLIANCE" OF THESE ARTISTS LIVING UNDER SUPPRESSIVE REGIMES — A VITALITY AND HUMAN EXPRESSION OF FREEDOM AND OPENNESS WHICH FORTUNATELY NEITHER HITLER NOR HIS REGIME WAS ABLE TO EXTINGUISH.

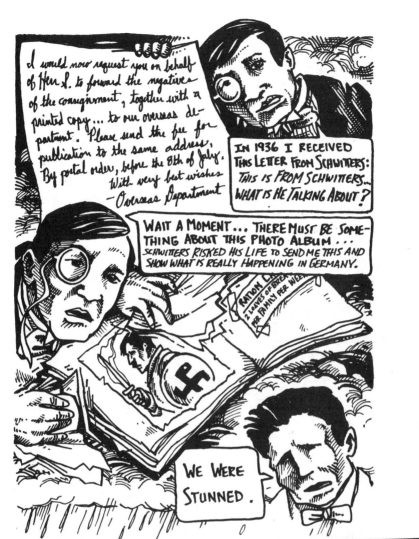

{59

Dada history is varied, passionate, highly controversial, contradictory, bold...and filled with vitality. But more recently, scholars are beginning to look at Dada art and consider the extensive influences of this short-lived but amazing group.

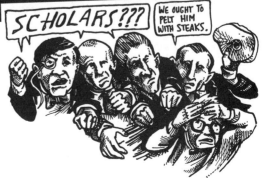

Although Dada was short-lived as a movement and is often discussed primarily as a precursor to Surrealism, perhaps at this point it is important to recognize its contributions and influences outside of Surrealism. There is little question that it was tremendously influential for a huge variety of works such as Pop Art, Situationist Art, and performance art.

And now for the question of what happened to Dada. Did Dada die? Or does Dada still exist?

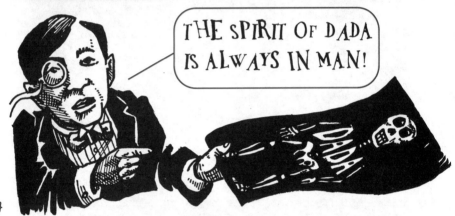

THE SPIRIT OF DADA IS ALWAYS IN MAN!

While it may be true that the Dada spirit is always with us and is part of what it means to be human, it is also true that as a movement, Dada faded quickly. Despite its passion and energy, one could argue that there is only so far that such a negative and maniacally charged movement could go.

But here's some proof that the Dada spirit is not dead: When an art museum in Detroit attempted to "recreate" a Dada event in 2002 (featuring Yoko Ono), the Detroit Metro Times reported that the exhibition (which, evidently, was supposed to be Dada but a sort of properly controlled version of Dada) spun out of control, with reproductions of the art being destroyed.

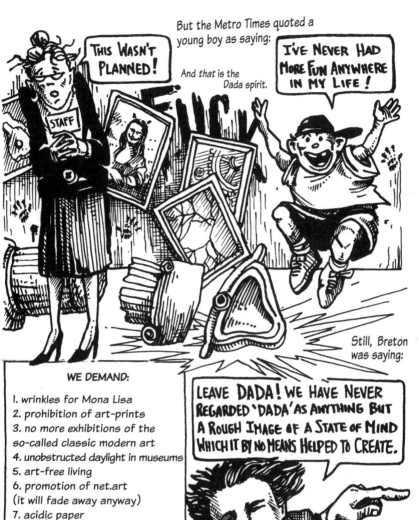

PURE SURREALIST JOY

Perhaps the climactic fist fight between Tristan Tzara and André Breton foretold the "end" of Dada, at least from a standpoint of an artistic movement. But as with most art movements, one can't say exactly where Dada ends and Surrealism begins. Gradually, artists began to pull away from Dada.

And the leader who began to emerge, overshadowing Tzara, was André Breton.

Breton was every bit the artistic movement leader that Tzara was, and every bit as strong-willed. It was nearly inevitable that he and Tzara eventually clashed.

Born in Tinchenbray in northern France, Breton was the son of a shopkeeper—and, like many of the early Dada/Surrealists, he was from a relatively ordinary middle-class family (the very group whose values that the Dada/Surrealists viciously attacked). By several accounts, Breton's personality was described as fascinating, yet authoritarian—strange for an artistic leader attempting to assert certainfreedoms for the artist.

{63

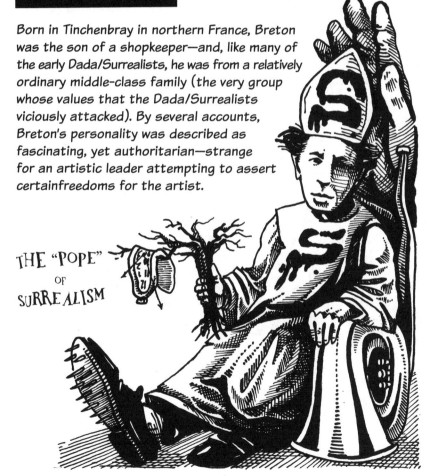

THE "POPE"
OF
SURREALISM

As the "Pope" of Surrealism, Breton had a temper and was known to lavish attention on an emerging artist only to write an angry "ex-communication" about the same artist a few months or years later (he also held the grudges that lasted years). Although Breton had a way of attracting new young artists to his side (and over many years at that), with time and with wars and perhaps distance breaking up the group, very few of the Dadas or Surrealists remained loyal to his following. Yet most did not wish to stray too far from his attention .

Regardless of Breton's character flaws, one could hardly consider writing about Dada or Surrealism without discussing him. Breton wrote his own Surrealist works in addition to writing *about* Surrealism.

After his skirmish with Tzara in Paris, Breton stopped participating in most Dada events. As Breton pondered the inadequacies of Dada, he still felt frustrated by the lack of imagination and spontaneity caused by the rational mind. In his First Manifesto of Surrealism, he writes:

64}

WE ARE STILL LIVING UNDER THE REIGN OF LOGIC: THIS, OF COURSE, IS WHAT I HAVE BEEN DRIVING AT. THE ABSOLUTE RATIONALISM THAT IS STILL IN VOGUE ALLOWS US TO CONSIDER ONLY FACTS RELATING DIRECTLY TO OUR EXPERIENCE. IT IS POINTLESS TO ADD THAT EXPERIENCE ITSELF HAS FOUND ITSELF INCREASINGLY CIRCUMSCRIBED. IT PACES BACK AND FORTH IN A CAGE FROM WHICH IT IS MORE AND MORE DIFFICULT TO MAKE IT EMERGE.

D.A. BOSS

Breton's argument is that absolute rationalism leaves no space for imagination, chance, whimsy, and perhaps even humor. If logic offers an orderly progression from one idea to the next, what about the *disorderly* imagination that makes connections between unrelated things? Where could one find inspiration now, without letting the art become stale, as even Dada had become? This question perplexed both Breton and other former Dadas/early Surrealists.

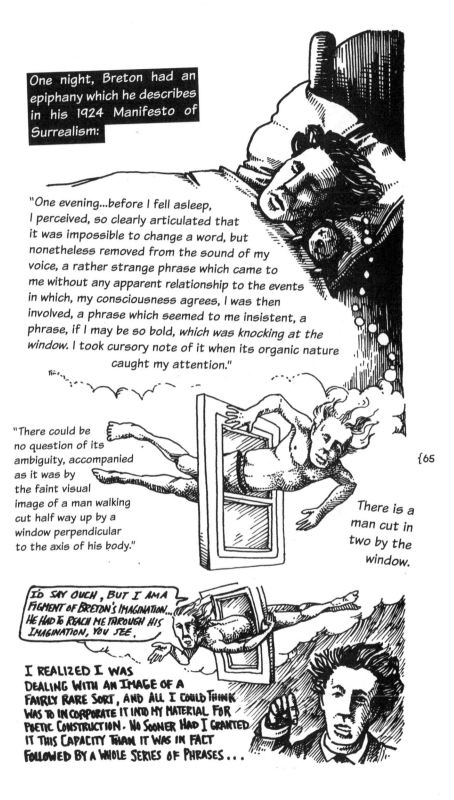

One night, Breton had an epiphany which he describes in his 1924 Manifesto of Surrealism:

"One evening...before I fell asleep, I perceived, so clearly articulated that it was impossible to change a word, but nonetheless removed from the sound of my voice, a rather strange phrase which came to me without any apparent relationship to the events in which, my consciousness agrees, I was then involved, a phrase which seemed to me insistent, a phrase, if I may be so bold, which was knocking at the window. I took cursory note of it when its organic nature caught my attention."

"There could be no question of its ambiguity, accompanied as it was by the faint visual image of a man walking cut half way up by a window perpendicular to the axis of his body."

{65

There is a man cut in two by the window.

ID SAY OUCH, BUT I AM A FIGMENT OF BRETON'S IMAGINATION... HE HAD TO REACH ME THROUGH HIS IMAGINATION, YOU SEE.

I REALIZED I WAS DEALING WITH AN IMAGE OF A FAIRLY RARE SORT, AND ALL I COULD THINK WAS TO INCORPORATE IT INTO MY MATERIAL FOR POETIC CONSTRUCTION. NO SOONER HAD I GRANTED IT THIS CAPACITY THAN IT WAS IN FACT FOLLOWED BY A WHOLE SERIES OF PHRASES ...

The most beautiful straws

HAVE A FADED COLOR

UNDER THE LOCKS

on an isolated farm

Watch out for

the fire that covers

THE PRAYER

of fair weather

I RESOLVED TO OBTAIN FROM MYSELF,... A MONOLOGUE SPOKEN AS RAPIDLY AS POSSIBLE, WITHOUT ANY INTERVENTION ON THE PART OF THE CRITICAL FACULTIES, A MONOLOGUE CONSEQUENTLY UNINHIBITED BY THE SLIGHTEST INHIBITION AND WHICH WAS, AS CLOSELY AS POSSIBLE, AKIN TO SPOKEN THOUGHT.

This last sentence expresses a key element of surrealism: an attempt to capture the way we think. And suddenly, there was the inspiration that he had been lacking: an inspiration of the unconscious mind!

Breton felt that with this experience, he had discovered a new artistic method, an *automatism*. Many former Dadas, frustrated by "the rational" as an overly suppressive system of thought, found the idea of turning inward to explore the *unconscious mind* new and fertile territory for artistic inspiration. Here was a new world that had been "discovered" when Dada turned its destructive ironies on the old.

Breton summed up surrealism with two different encyclopedia-like definitions in his first manifesto:

SURREALISM, n.
1. Psychic automatism in its pure state, by which one proposes to express—verbally, by means of the written word, or in any other manner—the actual functioning of thought. Dictated by thought, in the absence of any control exercised by reason, exempt from any aesthetic or moral concern.

2. Philosophy. Surrealism is based in the belief in the superior reality of certain forms of previously neglected association, in the omnipotence of dream, in the disinterested play of thought. It tends to ruin once and for all all other psychic mechanisms and to substitute itself for them in solving all the principal problems of life.

{67

Yet his definition of surrealism changed over time.

NEW INFLUENCES FOR SURREALISM

It is not surprising that Breton was the artist to "discover" new Surrealist territory for other artists and was also the one who cultivated it. Breton's medical and psychiatric training had led him to studies of the unconscious. During the First World War, he helped shell-shocked soldiers from the front recover, carefully studying and noting patterns among those with mental illness. (The extreme opposite of the rational, after all, is insanity.)

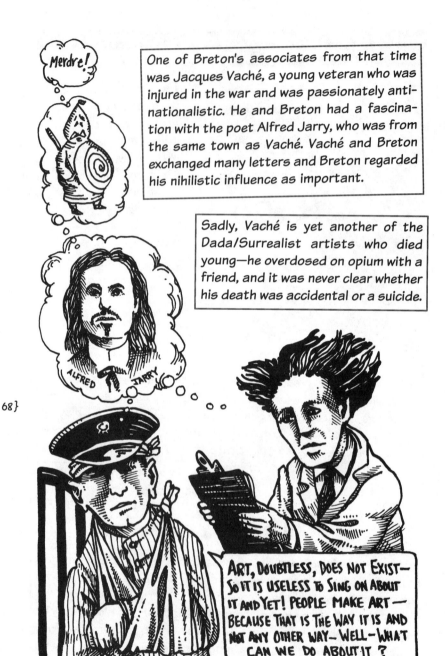

Merdre!

One of Breton's associates from that time was Jacques Vaché, a young veteran who was injured in the war and was passionately anti-nationalistic. He and Breton had a fascination with the poet Alfred Jarry, who was from the same town as Vaché. Vaché and Breton exchanged many letters and Breton regarded his nihilistic influence as important.

Sadly, Vaché is yet another of the Dada/Surrealist artists who died young—he overdosed on opium with a friend, and it was never clear whether his death was accidental or a suicide.

ALFRED JARRY

ART, DOUBTLESS, DOES NOT EXIST— SO IT IS USELESS TO SING ON ABOUT IT AND YET! PEOPLE MAKE ART— BECAUSE THAT IS THE WAY IT IS AND NOT ANY OTHER WAY— WELL—WHAT CAN WE DO ABOUT IT ?

Sigmund Freud was another important influence on the Surrealists. His work on the unconscious fascinated the Surrealists and they were intrigued by his recognition of the unconscious mind.

[THE DREAM IS] A PERFECTLY VALID PSYCHIC PHENOMENON, ACTUALLY A WISH-FULFILLMENT; IT MAY BE ENROLLED IN THE CONTINUITY OF THE INTELLIGIBLE PSYCHIC ACTIVITIES OF THE WAKING STATE; IT IS BUILT UP BY A HIGHLY COMPLICATED INTELLECTUAL ACTIVITY.

Note that here, Freud does not suggest that dreams are to be dismissed as "irrational"—rather he gives them credit as an independent and creditable activity of the mind—free from rational constraints.

Freud, however, was not fascinated by the Surrealists— at least he did not seem to give them much recognition or attention.

{69

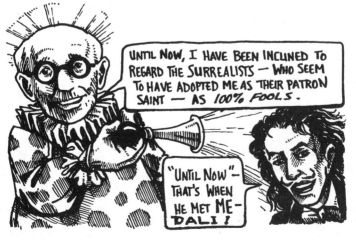

UNTIL NOW, I HAVE BEEN INCLINED TO REGARD THE SURREALISTS — WHO SEEM TO HAVE ADOPTED ME AS THEIR PATRON SAINT — AS 100% FOOLS.

"UNTIL NOW" — THAT'S WHEN HE MET ME — DALI!

(More about Dali later.)

THIS CLAIMING AND DENYING OF INFLUENCES IS SO BOURGEOIS!

The Surrealists were fascinated by three "areas" of Freud's unconscious mind: dreams, hypnosis, and madness. Each of these areas, they felt, held certain keys to the "automatism" they sought.

CAN'T THE DREAM ALSO BE USED IN SOLVING THE FUNDAMENTAL QUESTIONS OF LIFE?

Breton's Bureau of Surrealist Research began to engage in a variety of experiments in hypnosis. Robert Desnos emerged as one poet whose dream diaries were enormously influential among the Surrealists. He kept dream diaries as a child and while in a trance (a state which he both seemed to enjoy). These dream writings produced the kind of lyrical, disjointed, and, well, surreal imagery that the Surrealists were seeking.

WITH A THROBBING HEART WE STORM THE BREACH AT THE FRONTIERS
POPULOUS SUBURBS OVERFLOW WITH CHAMPIONS
LET US GO UP THE STREAMS OF NOCTURNAL CHANNELS
TO THE IMPASSIVE HEARTS WHERE OUR VOWS GO ASLEEP

VENTRICLE FLAGS TRUMPET OF THESE COUNTRIES
THE CHILD SPOILED BY LOVE OF OSTRICHES
WOULD NEVER HAVE FAILED IN THE DUTY OF DYING
IF BLUE STORKS WOULD LIQUEFY IN THE AIR

Many of the other Surrealists had difficulty being hypnotized and falling into trances, so Breton enthusiastically worked with Desnos for some time. He even dubbed him "the one who came closest to Surrealist truth," only to later, in typical Breton fashion, dismiss Desnos from the Surrealist movement for the journalism work that Desnos pursued. Nonetheless, Desnos remained a highly prolific artist throughout his lifetime. (Sadly, his journalism work later landed him in a concentration camp where he died.)

By *condemning many forms of work, Breton could make it exceedingly difficult for Surrealists of his group to earn a living. For many the solution was, apparently, to seek out wealthy women who supported their artistic habits. Breton himself was an art dealer who sometimes chose to live in poverty—while surrounded by highly valued paintings.*

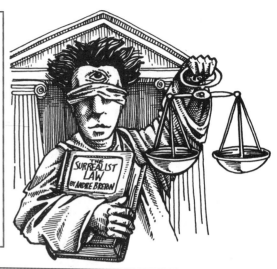

Josephson criticized Breton for "misusing psychoanalytic methods," and "trying to extract literature from the minds of persons in a state of hypnosis or sleep."

JOSEPHSON: I certainly would not have cared to be responsible for the troubled soul of a man like Desnos or one or two others of Breton's entourage who were plainly psychotic.

{71

Several sources indicate that Desnos, in his trances, became violent. He allegedly chased poets Ezra Pound and Paul Eluard with a knife. After that experience, plus instances where it proved difficult to awaken Desnos, plus one time where some hypnotized guests were attempting to hang themselves, Breton gave up experimenting with hypnosis.

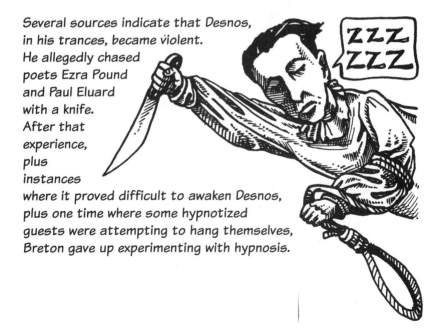

Breton and his colleagues also took special interest in the work of the mentally ill, exhibiting their pieces alongside the other artists.

I COULD SPEND MY WHOLE LIFE PRYING LOOSE THE SECRETS OF THE INSANE. THESE PEOPLE ARE HONEST TO A FAULT, AND THEIR NAIVETE' HAS NO PEER BUT MY OWN. CHRISTOPHER COLUMBUS SHOULD HAVE SET OUT TO DISCOVER AMERICA WITH A BOATLOAD OF MADMEN.

Breton's famous novel *Nadja* chronicles a love story about a young man's fascination with a young woman who later proves to be mentally ill. He speaks out for Nadja's fate:

[NADJA] HAS HAD TO BE COMMITTED TO THE VAUCLUSE SANATORIUM... THE ESSENTIAL THING IS THAT I DO NOT SUPPOSE THERE CAN BE MUCH DIFFERENCE FOR NADJA BETWEEN THE INSIDE OF A SANATORIUM AND THE OUTSIDE...

UNLESS YOU HAVE BEEN INSIDE A SANATORIUM YOU DO NOT KNOW THAT MADMEN ARE *MADE* THERE. IS THERE ANYTHING MORE DETESTABLE THAN THESE SYSTEMS [THAT]... SYSTEMATICALLY DEPRIVE [A PERSON] OF RELATIONS WITH EVERYONE WHOSE MORAL OR PRACTICAL SENSE IS MORE ESTABLISHED THAN HIS OWN?

Still another influence for the Surrealists (one unrelated to the unconscious) was a theme from the sexual underworld. The Surrealists held a fascination with the Marquis de Sade. While famous for the "sadism" that was named for him as well as novels that some still regard as pornographic (and violently pornographic at that), it was Sade's writings about freedom as it relates to sexual activity that drew the Surrealists. The Surrealists were intrigued by the possibility of being freed from conventional moralities (back to the Dada idea of escaping the bourgeois). They discussed sexuality openly in an era when this topic was still not socially acceptable, asking one another very frank questions, not just about sex but also about love.

The group had some affairs and experimental relationships among members. Perhaps most notable was Paul Eluard's wife's affair with Salvador Dalí. (Eluard never seemed to have quite recovered from this.) Still, as a group, the Surrealists were relatively conservative with such matters.

Though Breton often led and recorded these conversations, he could be rather prudish, and some sources suggest he was a homophobe.

EXQUISITE CORPSES

The Surrealists developed a variety of techniques for exploring the unconscious mind, and given that they were opposed to traditional work, they spent many hours cultivating and practicing these techniques. The partial aim of these games was free or chance association, which created unusual juxtapositions of images or words (or, in some cases, both). The Surrealists delighted in the spontaneity.

BRETON: The Surrealist atmosphere created by automatic writing, which I have wanted to put within the reach of everyone, is especially conducive to the production of the most beautiful images.

How does one produce automatic writing? In his First Manifesto, Breton advised practicing "automatic writing" like this:

"After you have settled yourself in a place as favorable as possible to the concentration of your mind upon itself, have writing materials brought to you. Put yourself in as passive, or receptive, a state of mind as you can. Forget about your genius, your talents, and the talents of everyone else. Keep reminding yourself that literature is one of the saddest roads that leads to everything. Write quickly, without any preconceived subject, fast enough so that you will not remember what you're writing and be tempted to reread what you have written. The first sentence will come spontaneously, so compelling is the truth that with every passing second there is a sentence unknown to our consciousness which is only crying out to be heard."

"Go on as long as you like. Put your trust in the inexhaustible nature of the murmur."

Compare this set of instructions to Tzara's instructions on making a Dada poem (cutting the random phrases from the newspaper and drawing them from a hat): the Surrealist game looks to the internal resources and unconscious mind of the artist rather than to the external world.

Another Surrealist game was called "The Exquisite Corpse." To play, a piece of paper was folded over onto itself many times so each player could write down a phrase or word without the other players reading the phrase that came before theirs.

The first game resulted in the phrase, "The exquisite corpse will drink the new wine," which led to the game being named "The Exquisite Corpse."

The Surrealists delighted in both the collaborative and "chance" aspects of the game, and extended the game to include drawing. Pictures were drawn on blind panels and then assembled into one drawing. One player would draw a head and neck, the next the torso, the next the legs, and finally the feet. The result might look like this Exquisite Corpse (by Man Ray, Tanguy, Miro, and Morise):

THE PLAYFUL TECHNIQUES USED TO PRODUCE ME ARE NOTHING NEW TODAY, AND ARE PARLOR GAMES — IN FACT THEY ARE A GAME THAT CHILDREN MIGHT PLAY — BUT CERTAINLY I WAS QUITE ORIGINAL IN MY DAY, AND THE SURREALISTS TOOK SUCH WORK SERIOUSLY.

While both Dada and Surrealism were multidisciplinary movements, Dada was dominated by performance and visual art while the early Surrealists were mostly writers. Musicians were among the fewest artists, although Dada could claim musician Eric Satie (who wrote music that was not supposed to be listened to). A few other musicians also circulated among the group. Later, musicians such as John Cage were influenced by Dada. Cage is famous for a piece where a "pianist" sits poised as if about to play. Instead, the audience's sounds become the music.

{75

With this style of performance, we can see how Cage defies audience expectations in a similar manner to the Dadas.

(Some scholars point out that Breton was tone-deaf, which may partially account for the scarcity of musicians in the movement.)

DADA AND SURREALISM: SIMILARITIES AND DIFFERENCES

Surrealism didn't possess the angry, destructive tone of Dada. Regardless, Dada was one of Surrealism's precursors. Surrealism shared Dada's scorn of the bourgeois, and both movements shared a common desire to tear down the rational, elevate the irrational, and delight in chance and randomness. But Surrealism parted ways from Dada in a number of important aspects. Surrealism wanted to rehabilitate and rebuild the arts and foster a certain collective effort.

Breton's Surrealists initially called themselves the Bureau of Surrealist Research, which was a collaborative effort. Breton's Bureau of Surrealist Research referred not just to a group of artists working on individual pieces, but to various group projects (such as the exquisite corpses). Much of the early Surrealist experimentation was highly collaborative in nature. Dada, on the other hand, was more tolerant of individual expression. Further indicating a desire for collaboration, the "Bureau" was open to the public.

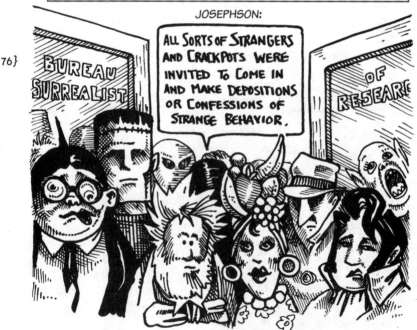

JOSEPHSON:

ALL SORTS OF STRANGERS AND CRACKPOTS WERE INVITED TO COME IN AND MAKE DEPOSITIONS OR CONFESSIONS OF STRANGE BEHAVIOR.

(Josephson was eventually denounced by Breton, which may explain some of the disdain.)

Another key difference between Dada and Surrealism is the concept of the marvelous, something the Surrealists were constantly striving to attain.

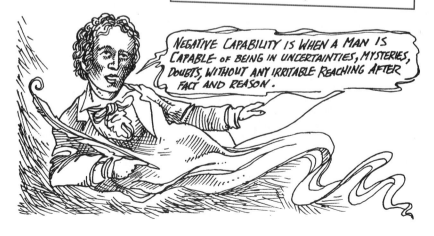

Marvelous

BRETON: LET US NOT MINCE WORDS: THE MARVELOUS IS ALWAYS BEAUTIFUL, ANYTHING MARVELOUS IS BEAUTIFUL, IN FACT ONLY THE MARVELOUS IS BEAUTIFUL.

Breton's "marvelous" carries echoes of Romanticism. You could say, for example, that British poet John Keats's concept of "negative capability" is similar to the concept of the marvelous:

In Breton's view, which he describes in his 1924 Manifesto of Surrealism, the marvelous was a quality of a work that "exercises an exalting effect only upon that part of the mind which aspires to leave the earth", suggesting that Surrealism has a transcendentalist aspect to it...and so perhaps (UNLIKE Dada) a purpose? While the Dadas resisted the suggestion of a purpose or aspiration, the newly-formed Surrealists invented a new category of meaning called "the marvelous," which was the very of pinnacle of Surrealist experience. A work of Surrealism NEEDED to be marvelous—unlike a Dada work which had no such aspiration.

{77

NEGATIVE CAPABILITY IS WHEN A MAN IS CAPABLE OF BEING IN UNCERTAINTIES, MYSTERIES, DOUBTS, WITHOUT ANY IRRITABLE REACHING AFTER FACT AND REASON.

THERE IS A WILLINGNESS ON KEATS' PART TO ACCEPT A LACK OF REASON AS PART OF WHAT IT MEANS TO BE HUMAN AND IMAGINATIVE.

Both "negative capability" and "the marvelous" reflect a tolerance of ambiguities and uncertainties.

SURREALIST FACTIONS

In 1924, the Surrealists launched a journal called *Surrealist Revolution*. Up to this point, the type of revolution that Surrealism offered was general, with sympathy for the Left and a sharp distaste for bourgeois values. With political tensions on the rise yet again throughout Europe (early rumblings of WWII), the Surrealists developed a deep ideological rift: was this an artistic movement or a political movement? If, after all, Surrealism was a revolution, what kind of revolution was it?

Both the Dadas and Surrealists shared certain affinities with anarchists, and had emphasized individual freedom to this point. Now the question became difficult: was there any point in getting a bunch of artists to unite in a climate where speaking out could be dangerous and difficult, as well as not necessarily conducive to Surrealist *artistic* activity?

I HAVE ALWAYS PLACED THE SPIRIT OF REVOLT WELL BEYOND MERE POLITICAL ACTION.

Yet Aragon broke from the Surrealists in what became known as "The Aragon Affair," joining the Communist party (as did many other Surrealists), thus placing his political commitment over the artistic movement and, of course, bringing down Breton's wrath.

Surrealism held the seeds of revolution, and needed to do something with them. So along came Breton's *Second Manifesto of Surrealism* (1930). In this manifesto, notice the emphasis on revolution as opposed to "the marvelous" that he stressed in the First Manifesto:

SURREALISM ATTEMPTED TO PROVOKE, FROM THE INTELLECTUAL AND MORAL POINT OF VIEW, AN ATTACK ON CONSCIENCE...THE EXTENT TO WHICH THIS WAS OR WAS NOT ACCOMPLISHED ALONE CAN DETERMINE ITS HISTORICAL SUCCESS OR FAILURE. IT IS NOT THE MAN WHOSE REVOLT BECOMES CHANNELED AND RUNS DRY WHO CAN KEEP THIS REVOLT FROM RUMBLING ... THERE ARE STILL TODAY ... PURE YOUNG PEOPLE WHO REFUSE TO KNUCKLE DOWN.

{79

AND IN THIS MANIFESTO, BRETON DECIDED TO "ABANDON SILENTLY" A NUMBER OF HIS FORMER FRIENDS WHOM HE NAMES, INCLUDING ME OF COURSE.

BUT IN HIS SECOND MANIFESTO, HE PRAISES MY POETRY, EVEN AFTER ALL HIS CRITICISM.

Perhaps Breton's most famous comment from this manifesto is:

THE SIMPLEST SURREALIST ACT CONSISTS OF DASHING DOWN THE STREET, PISTOL IN HAND, AND FIRING BLINDLY, AS FAST YOU CAN PULL THE TRIGGER, INTO THE CROWD.'

But it's important not to take this quotation out of context, as he adds this:

Anyone who has not, at least once in his life, dreamed of putting an end to the petty system of debasement and cretinization in effect has a well-defined place in that crowd, with his belly at barrel level.

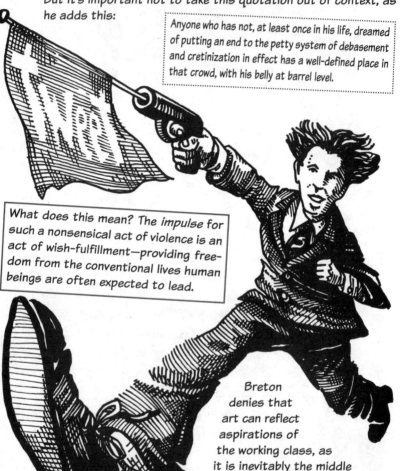

What does this mean? The impulse for such a nonsensical act of violence is an act of wish-fulfillment—providing freedom from the conventional lives human beings are often expected to lead.

Breton denies that art can reflect aspirations of the working class, as it is inevitably the middle class that produces art and thus cannot reflect those aspirations. Yet he had allegiances to the Communist Party, and changed the name of his journal to Surrealism in Service to the Revolution.

Breton's association with the Communists was short-lived. With his loyalty in question and his ability (and willingness) to provide some kind of actual service doubtful, he was asked to leave.

With the Second World War brewing and political expression touchy and dangerous, Breton and many of the other Surrealists eventually fled to the United States.

But the movement had brought in some new recruits, including an artist/showman who eventually replaced Breton as spokesman for Surrealism and whose name is now synonymous with Surrealism:

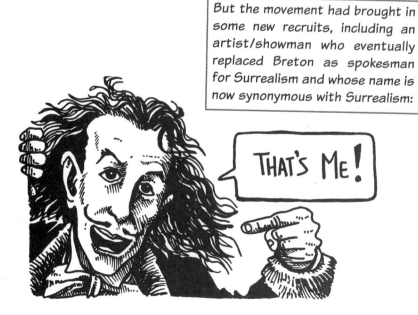

CHAPTER FIVE

MADMEN, MAGRITTE, MOODS, AND SURREALIST GLOWS IN THE EYES OF WOMEN

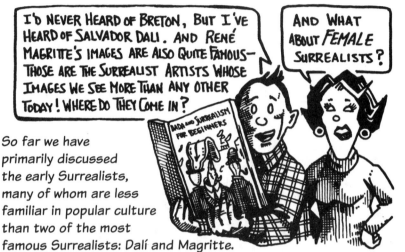

> I'D NEVER HEARD OF BRETON, BUT I'VE HEARD OF SALVADOR DALI. AND RENÉ MAGRITTE'S IMAGES ARE ALSO QUITE FAMOUS—THOSE ARE THE SURREALIST ARTISTS WHOSE IMAGES WE SEE MORE THAN ANY OTHER TODAY! WHERE DO THEY COME IN?

> AND WHAT ABOUT *FEMALE* SURREALISTS?

So far we have primarily discussed the early Surrealists, many of whom are less familiar in popular culture than two of the most famous Surrealists: Dalí and Magritte.

(And yes, there were a number of female Surrealists, whom we discuss later in a bit more detail.)

{83

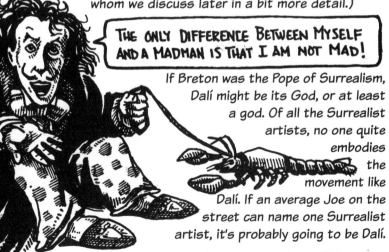

> THE ONLY DIFFERENCE BETWEEN MYSELF AND A MADMAN IS THAT I AM NOT MAD!

If Breton was the Pope of Surrealism, Dalí might be its God, or at least a god. Of all the Surrealist artists, no one quite embodies the movement like Dalí. If an average Joe on the street can name one Surrealist artist, it's probably going to be Dalí.

> YEP, HEARD OF HIM

Dalí was born in Spain, close to the French border. When he was born, he was given the same name as an infant brother who had died shortly before he was born. His schooling was difficult and he was eventually thrown out of school because he said his teachers were not capable of assessing his work.

Dalí erupted onto the Surrealist scene in 1929 with a film he produced with Louis Buñuel, *An Andalusian Dog*, and he joined the Parisian Surrealists the same year. No one can deny that Dalí's flair and flamboyance allowed him to overshadow Breton as spokesperson (or "showman") for Surrealism.

WITH THE COMING OF DALI, IT IS PERHAPS THE FIRST TIME THAT THE MENTAL WINDOWS HAVE BEEN OPENED REALLY WIDE, SO THAT ONE CAN FEEL ONE'S SELF GLIDING UP TOWARDS THE WILD SKY'S TRAP.

An Andalusian Dog is a short film meant to capture a dream-like state. It begins with a man sharpening a razor and a cloud passing over the moon, but is perhaps best known for a startling scene where a woman's eye is cut open (a cow's eye was used), reflecting the image of the cloud passing the moon. Another striking image included a donkey carcass in a grand piano, being pulled along by a man.

Dalí developed what he called a "paranoid critical transformation" method for human perception. He was able to put himself into a paranoid state—without drugs or hypnosis—and use that state to find what he termed "double images" in the world around him.

I DON'T DO DRUGS. I AM DRUGS.

Then he painted what he experienced. Caws quotes Dalí writing to Gala Eluard:

> The paranoiac mechanism whereby the multiple image is released is what supplies the understanding with the key to the birth and origin of all images...it is by their failure to harmonize with reality, and owing also to the arbitrary element of their presence, that images so easily assume the forms of reality.

Or if we were to translate, he might be saying "I paint like a madman on purpose."

Dalí's fascination with the paranoid-mad led him to Freud, who was impressed with him.

{85

YES, EVEN IF HE DID DRAW MY HEAD TO LOOK LIKE A SNAIL SHELL.

MY MEETING WITH FREUD DID NOT GO WELL.

Dalí's themes and tastes varied wildly—he created representations of madness, fried eggs, the back of Hitler's neck, burning giraffes, lobster phones, and sofas made of lips. His *Persistence of Memory*, with soft or melting clocks, is among his most famous of works.

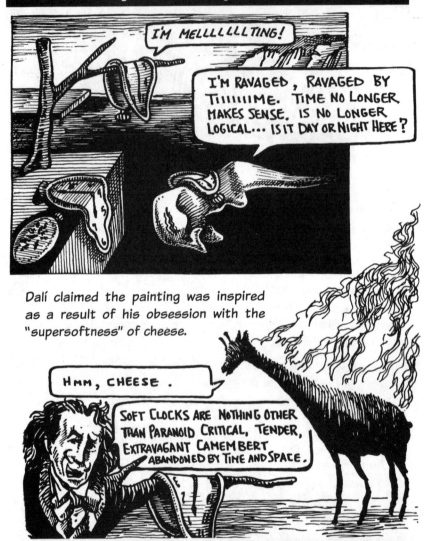

Dalí claimed the painting was inspired as a result of his obsession with the "supersoftness" of cheese.

The war drove Dalí to the United States, as it did Breton and other Surrealists. Gradually the other Surrealists became annoyed with Dalí (and perhaps jealous, as Dalí attracted attention and fame—and financial success—in the United States, working on everything from ballets to fashion magazines).

There is a disturbing question as to whether Dalí supported the Nazis. Dalí claimed to be intrigued by Hitler from an *aesthetic* and *apolitical* standpoint, and in reading his comments, one cannot help but wonder if Dalí is subtly mocking the Nazis and Hitler. There is little question that he had a fetish-like interest in Hitler, which the other Surrealists could not tolerate, leaving *them* in the curious position of looking, well, intolerant.

In 1934, Dalí was put on "trial" by other Surrealists, where his Hitler fetish became part of the proceedings, described by Gilles Néret like this:

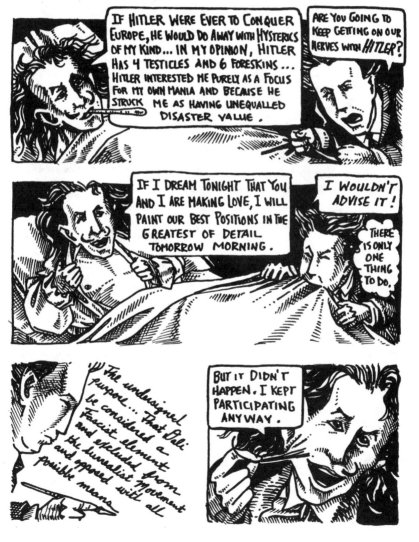

While the Hitler fetish was baffling, modern readers might be startled to learn that Dalí also collaborated with Walt Disney. It sounds, well, surreal—our modern-day associations with Disney are...cute. As anyone who has seen Dalí's work could attest, his work was not "cute." What would such collaboration look like?

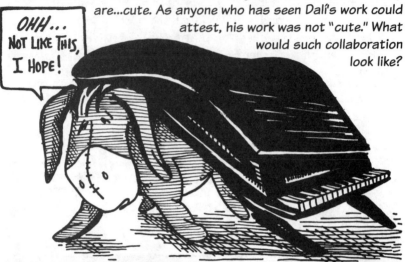

OHH... NOT LIKE THIS, I HOPE!

The project was abandoned due to an anticipated lack of public interest. However, it was released in 2003 under the name, *Destino* and won various film awards.

And so it was that Dalí "outsurrealed" the Surrealists, including Breton.

MAGRITTE

THE DIFFERENCE BETWEEN ME AND THE SURREALISTS IS THAT I AM SURREALISM.

If Dalí is one typically recognizable Surrealist name, René Magritte might be the other. Unlike the flamboyant and self-promoting Dalí, Magritte was said to be quiet and refined. His wife Georgette was his only model for his paintings.

While both artists are recognizably "Surrealist," the two men seemed to have been very different in terms of personality, which is reflected even in their appearance.

Magritte was Belgian and grew up in an industrial town (which he eventually abandoned for Brussels). His mother committed suicide when he was a child. (He remembered her face being covered with a handkerchief, and several of his paintings show people with faces covered by handkerchiefs). He became interested in Dada and then Surrealism in the 1920s while he attended Surrealist gatherings with his wife Georgette, he seems to have been somewhat removed from the other Surrealists.

Magritte is a master of juxtaposition (placement of objects within the picture). His paintings juxtaposed images to create surreal moments that can surprise and charm—or surprise and disturb. He called this "poetry." As you gaze at a Magritte painting, you might sense an aftereffect: something is amiss, or something made you laugh, but it takes a while to determine just what caused that effect on you.

One of Magritte's most famous paintings is of a pipe, with perfect cursive text underneath it that says "This is not a pipe."

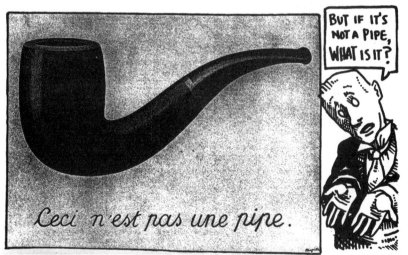

BUT IF IT'S NOT A PIPE, WHAT IS IT?

{89

Ceci n'est pas une pipe.

It's a *depiction* of a pipe. The word "pipe" does not constitute the pipe itself; it's just a description that is ultimately arbitrary to the object.

SURREALIST THEMES AND MOODS

Certain themes and moods prevail and emerge throughout Surrealist works. Where and how does one look for the marvelous in their work?

RANDOM WANDERINGS, JOURNEYS, AND COLLECTIONS

Wandering without a true destination is a common Surrealist theme. Some Surrealists took the journey in their own lives, wandering through flea markets and junk shops to find marvelous collections and turned them into art.

The Surrealists, like the Dadas, delighted in the idea of chance. The idea of a pointless journey of pure discovery was marvelous to them.

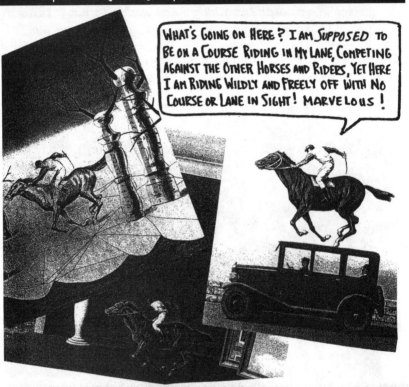

WHAT'S GOING ON HERE? I AM *SUPPOSED* TO BE ON A COURSE RIDING IN MY LANE, COMPETING AGAINST THE OTHER HORSES AND RIDERS, YET HERE I AM RIDING WILDLY AND FREELY OFF WITH NO COURSE OR LANE IN SIGHT! MARVELOUS!

Or just think of Breton's idea of Christopher Columbus setting off with a boatload of madmen, yet another example of the marvelousness of the journey...

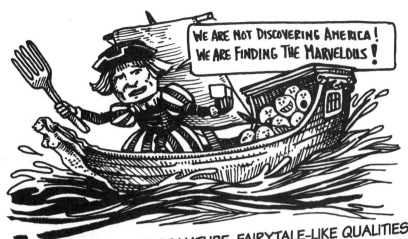

WE ARE NOT DISCOVERING AMERICA! WE ARE FINDING THE MARVELOUS!

SUSPENSION OF LAWS OF NATURE, FAIRYTALE-LIKE QUALITIES

Fairy tales often have talking animals, mysterious castles, and laws of nature suspended, infusing the stories with magic. Surrealist artwork often has a magical or fairy tale imaginative quality about it. This castle by Magritte would be an amazing setting for any fairy tale.

I'M FAR AWAY, INACCESSIBLE BY ANY LOGICAL ROUTE (EXCEPT PERHAPS THE IMAGINATION).

THERE ARE FAIRY TALES TO BE WRITTEN FOR ADULTS, FAIRY TALES STILL ALMOST BLUE.

Sometimes Surrealist landscapes take on a curiously unpopulated and foreboding sense that a dream might have. When you view Surrealist art, you may ask yourself, is it day or night? Do people appear? The artist Giorgio de Chirico painted some work of his most well-known work considerably earlier than the Surrealist movement, but many of his works inspired the Surrealists and the Dadas. *Mystery and Melancholy of a Street* is a good example of a strangely foreboding Surrealist setting—nothing playful about it.

I'M PLAYING WITH A HOOP IN THE STREET... BUT WHAT IS THAT SHADOW IN THE CORNER?!

Paul Delvaux and Magritte also introduce peculiar and disturbing scenes. Delvaux's *The Village of the Mermaids* shows the "mermaids" sitting outside in neat rows, but they completely lack both the associated grace and eroticism of mermaids. In fact, because their skirts obscure our view of their legs (or fin?), we are not sure if they are indeed mermaids.

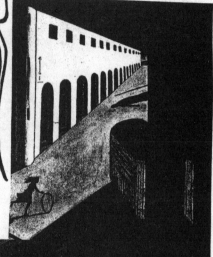

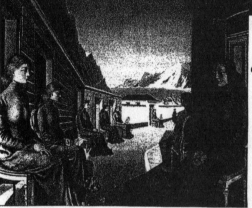

IT IS AS IF SOMETHING IS ABOUT TO HAPPEN HERE...

OR HOW ABOUT ME? WHY DO I HORRIFY YOU WHEN OTHER TRADITIONAL MERMAIDS ARE EROTIC?

MAGRITTE'S MERMAID

Other ways that laws of nature are suspended can be seen in the distorted perspectives of Magritte's giant flowers filling a room, or Dalí's burning giraffe.

THE GROTESQUE, ABSURD, AND HUMOROUS

Like the Dadas, the Surrealists were not concerned about conventional prettiness in their pictures. Dalí's work can be sometimes described as "grotesque" or "absurd." His *Soft Construction with Boiled Beans: A Premonition of Civil War* has a distorted, grotesque figure in severe pain—nothing to hang over the couch.

Magritte, too, depicts scenes where absurdity and grotesqueness reign, and where otherwise "respectable" elements are so wildly juxtaposed that one is left both a little bit disturbed, yet at times can't help but laugh.

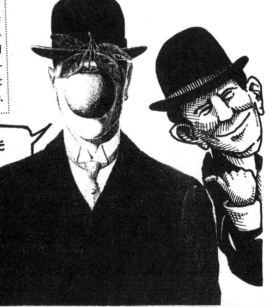

I AM A RESPONSIBLE MIDDLE-CLASS MAN, AS YOU CAN SEE BY MY ATTIRE. WHY DO I GET AN APPLE IN FRONT OF MY FACE? WHY?

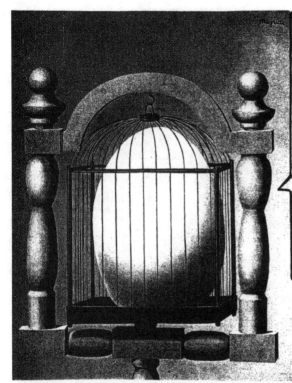

DO I "MAKE SENSE" IN A STRANGE WAY? A BIRD IN A CAGE MAKES SENSE TO YOU; WHY NOT AN EGG? OR DO I JUST MAKE YOU LAUGH, PERHAPS, WITH THE PAINTING'S TITLE, *ELECTIVE AFFINITIES* WHICH SUGGESTS THAT WE CAN ACCEPT THE AFFINITY BETWEEN BIRD-CAGE OR BIRD-EGG ASSOCIATION — BUT NOT EGG-CAGE?

BLENDING OF ORGANIC AND HUMAN OR HUMAN-MADE

The Dada interest in machines perhaps carried over to the Surrealists, who depicted not just outlandish creatures but creatures that were part human, part animal, or part machine.

Or in the case of Joan Miro, we see a figure that looks organic, like an amoeba under a microscope, or in some ways, like a *celestial universe.*

I LOOK MORE LIKE AN AMOEBA THAN A PERSON.

Or we might look at some lines of Breton's poem, "Free Union," which shows the blending of a woman with other creatures and manmade objects:

My wife with buttocks like a swan's back
My wife with legs of rocket
My wife with the waist of an otter in the tiger's teeth.

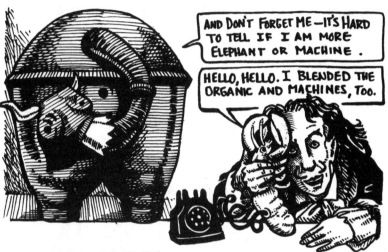

AND DON'T FORGET ME—IT'S HARD TO TELL IF I AM MORE ELEPHANT OR MACHINE.

HELLO, HELLO. I BLENDED THE ORGANIC AND MACHINES, TOO.

THE SURREALIST GLOW IN THE EYES OF WOMEN

Surrealists' commentary on women suggest that women are seen as somehow closer to the unconscious and in some ways superior...and yet inferior. Aragon talks about a "Surrealist glow in the eyes of women." The idea seemed to be that women were naturally less rational and therefore somehow closer to the Surrealist ideal.

Was Surrealism primarily a movement for men? No—the Surrealists had among them a number of women artists, many of whom attained fame in their own right. In many instances, they were companions to the male artists or served as models for them, and then began to create works of art on their own.

Women are also seen as child-muses, or as the "Other." The challenge of this label for the women artists was how to develop their own muses and inspirations for their own work.

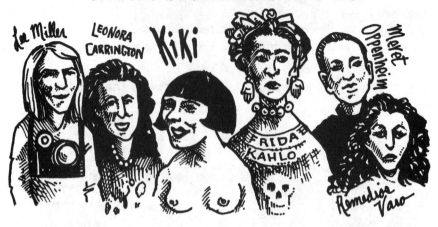

Lee Miller
LEONORA CARRINGTON
KiKi
FRIDA KAHLO
Meret Oppenheim
Remedios Varo

The Surrealists seemed to hold that women made good muses. The cover of one of the Surrealist magazines shows the Surrealists, eyes closed, arranged to surround a naked woman, as if they were dreaming of her and she was their inspiration.

96}

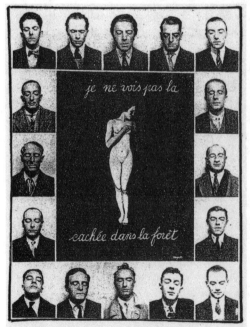

je ne vois pas la

cachée dans la forêt

(This cover was by Magritte and titled *I Do Not See the Woman Hidden in the Forest*.)

Surrealism is sexually charged but scholars also question if it is misogynistic. In their portrayals of women, male Surrealists "allowed" women to express themselves as sexual beings, which was still a taboo idea for the time. On the other hand, they do not always portray the women as full human beings either, and can be objectifying.

When asked about the question of female autonomy when it comes to sex, Breton was baffled. As we saw earlier, he wrote the following poem (excerpted) for his romantic interest Suzanne Muzard:

With an hourglass waist
My wife with the waist of an otter in the tiger's teeth
My wife with the mouth of cockade and of a bouquet of
 stars of the first magnitude
With teeth of spoors of white mice on the white earth
With a tongue of rubbed amber and glass

But the object of his interest responded:

Breton overflattered his loves; he molded the woman he loved so she should correspond to his own aspirations and thus become, in his eyes, an affirmed value. But I was only an object of disappointment since I was unadaptable to what he wanted me to be.

There is also the question of misogyny in Surrealist work (perhaps the influence of de Sade), as might be exemplified by a piece like Man and Woman by Alberto Giacometti.

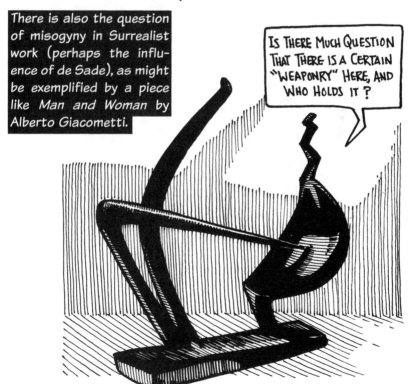

IS THERE MUCH QUESTION THAT THERE IS A CERTAIN "WEAPONRY" HERE, AND WHO HOLDS IT?

{97

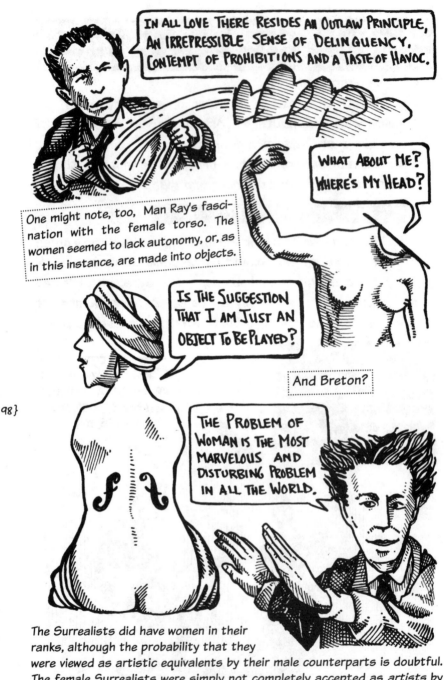

The Surrealists did have women in their ranks, although the probability that they were viewed as artistic equivalents by their male counterparts is doubtful. The female Surrealists were simply not completely accepted as artists by the male members of the movement. Many of these women were more successful working on their own, separate from the other Surrealists.

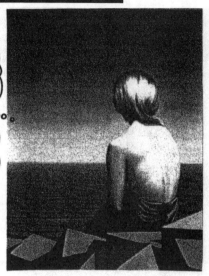

EVEN THOUGH YOU SEE JUST MY BACK, THE MOOD EVOKED IS ONE THAT'S LONGING, WISTFUL, DREAMING OF SOMETHING IN THIS LANDSCAPE AS I LOOK FAR OUT TO SEA. ONE SENSES A SADNESS ABOUT ME- I HAVE EMOTIONS AND A MIND.

Frida Kahlo is perhaps one of the better-known female Surrealists (though she, like many of the Surrealist women, might not have called herself a Surrealist).

Kahlo suffered a horrific accident in a trolley car when she was a child and spent most of her life in pain. She later suffered from miscarriages and health problems. Consider how her images also differ from male Surrealist images of women.

{99

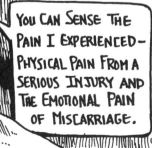

YOU CAN SENSE THE PAIN I EXPERIENCED- PHYSICAL PAIN FROM A SERIOUS INJURY AND THE EMOTIONAL PAIN OF MISCARRIAGE.

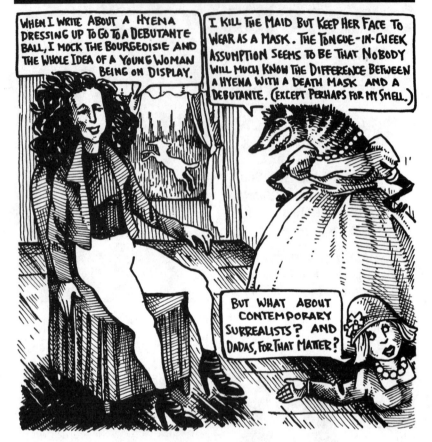

WHEN I WRITE ABOUT A HYENA DRESSING UP TO GO TO A DEBUTANTE BALL, I MOCK THE BOURGEOISIE AND THE WHOLE IDEA OF A YOUNG WOMAN BEING ON DISPLAY.

I KILL THE MAID BUT KEEP HER FACE TO WEAR AS A MASK. THE TONGUE-IN-CHEEK ASSUMPTION SEEMS TO BE THAT NOBODY WILL MUCH KNOW THE DIFFERENCE BETWEEN A HYENA WITH A DEATH MASK AND A DEBUTANTE. (EXCEPT PERHAPS FOR MY SMELL.)

BUT WHAT ABOUT CONTEMPORARY SURREALISTS? AND DADAS, FOR THAT MATTER?

100}

CHAPTER SIX
DADA AND SURREALISM TODAY

World War II subdued Dada and Surrealist activity, with many of the artists relentlessly pursued by various regimes, killed, or going into exile. Many European Surrealists did not adapt well to life in the United States (Breton refused to learn English, for example). Many longed for their home countries and eventually returned to Europe.

Writes Timothy Shipe, a keeper of the Dada archives in Iowa:

But there is little question that both Dada and Surrealism were tremendously influential movements of the 20th century, and modern and contemporary artists both extended the movement and continue to look to both movements for inspiration.

Contemporary art as we know it could not have come into existence without Dada. Virtually every artistic principle and device which underlies the literature, music, theater, and visual arts of our time was promoted, if not invented, by the Dadaists: the use of collage and assemblage; the application of aleatory techniques; the tapping of the artistic resources of the indigenous cultures of Africa, America, and Oceania; the extension of the notion of abstract art to literature and film; the breaking of the boundaries separating the different art forms from one another and from "everyday life"; the notion of art as performance; the expropriation of elements of popular culture; the notion of interaction or confrontation with the audience—everything which defines what we loosely call the "avant-garde."

{101

NEO-DADA

While we can see the influences of the early Dadas on the Neo-Dadas, the Neo-Dadas moved in a different direction, one with perhaps more humor, sarcasm, and celebration than Dada itself. As Richter puts it, "[Neo-Dada] is neither art nor anti-art but objects to be enjoyed."

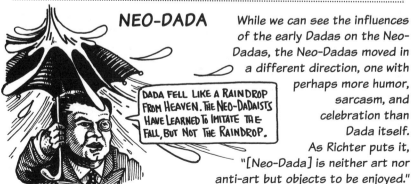

DADA FELL LIKE A RAINDROP FROM HEAVEN. THE NEO-DADAISTS HAVE LEARNED TO IMITATE THE FALL, BUT NOT THE RAINDROP.

The cool comic book enlargements of Roy Lichtenstein embody the immediacy and perhaps also the mocking mood of the Dadas. The woman in his painting who would rather drown (dramatically) than call a lover for help is more concerned with perpetuating and bringing to light male and female stereotypes than of following in the Dada tradition of meaning nothing.

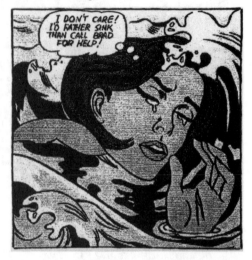

Or in Marisol's *Love*, a plaster and glass image of a reclining nose and mouth deep-throated by a Coca Cola bottle, you see the disturbing juxtaposition of Surrealism, but the overall effect of the piece is a more friendly state of mind of a popular consumer product instead of the dream world.

HAPPENINGS

"Happenings," live art events of the 1960s, were quite inspired by Dada. Happenings were usually street performances and often involved the audience. Richter writes about one such event in 1963 in a flophouse in New York:

EMPTY SACKS AND CARDBOARD BEGAN TO FALL OUT OF THE NIGHT SKY ... AND WE NOTICED A CYCLIST WHO WAS VERY SLOWLY RIDING ROUND AND ROUND AND ROUND THE GIANT SCAFFOLD ... AN OPHELIA IN WHITE BEGAN TO DANCE, WITH A TRANSISTER RADIO HELD TO HER EAR, ROUND THE SCAFFOLD THAT NOW LOOKED LIKE A SACRIFICAL ALTAR ... UP ABOVE, OPHELIA WAS PHOTOGRAPHED IN PROVOCATIVE POSES; ONLY HER LEGS WERE VISIBLE FROM BELOW.

A ritual! It was a composition using space, color, and movement.

As with Dada, happenings were theatrical and multidisciplinary performances where the audience was often engaged.

POP ART

The term "Pop Art" is said to have first been coined by an Englishman named Alloway. Pop Art delights in unsavory (perhaps bourgeois?) media like advertising and comic strips.

Keep in mind that bourgeois parents everywhere wanted to keep their kids from reading too many comic books. But Pop Art asks us to reconsider the role of the comics, advertising, and even the factory as it pertains to art.

Andy Warhol is among the most famous of Pop artists.

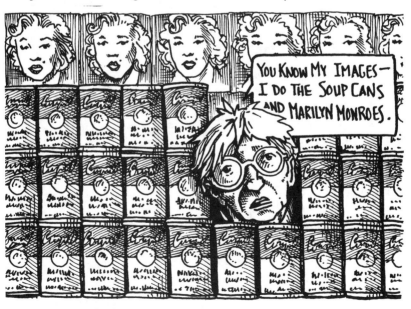

In the tradition of the ready-made, Warhol does not displace the notion of the object in the gallery, but strives to implant it in one's memory through repetition and easily recognized icons. Warhol's pop art transforms the idea of ready-mades into tangible objects we have encountered thousands of times while at the same time placing us in a state of odd limbo as we gaze at soup cans in an unfamiliar context (like a museum).

Andy Warhol sets such expectations in the guise of consumer redundancy, but he differs from the Dadas in the sense that he does not try to annihilate the viewer's conception of museum art.

ROCK N' ROLL

More often than not, knee-jerk connections are made between music and art. Although Dada and Surrealist art has unquestionably influenced current writers and artists, the movement's effect on music is less obvious. But sometimes it's fun to bridge this gap, even if it's in a searching way.

Although the Sex Pistols probably never studied Dada, their romantic temperament and penchant towards anarchy shares in the Dada spirit. Punk rock was, in part, a reactionary statement against the idealistic vision of the late sixties. The Sex Pistols preferred to tour the deep South, where they were hated, so they could convert the unconverted rather than conform to cultural norms, even if it meant having beer bottles and garbage thrown at them.

104}

Yes, I know all about that.

SOUPAULT

Anarchy seemed a surprisingly appropriate theme to a youth movement that was fed up with hierarchical institutions and the idealism of the previous generation that was no longer an effective or original response to change. Are the angry rebellious thumping chords of punk music much different in spirit than the Dadas' anger and disillusionment with authority?

SITUATIONIST ART

The Situationist Art movement of the late 1950's through 1980's looked to decenter its viewers from what member Guy Debord called "the spectacle." "The Spectacle" (loosely defined) could be the current vogue capitalist pop culture idea of the moment, destined to shift to another spectacle at the first sign of waning consumer interest.

Debord also discusses "détournement," his way of forcing viewers to acknowledge (and thus perhaps dissolve) the "spectacle."

For example, a Situationist artist might take a pop culture photo or icon and add a voice bubble to it, with startling commentary.

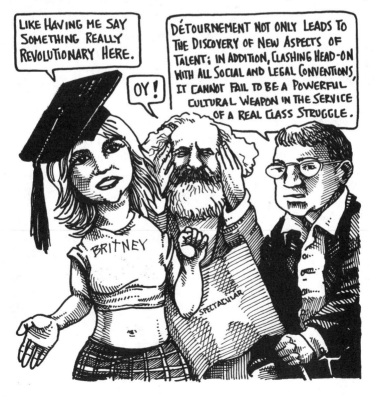

POP SURREALISM AND UNDERGROUND ART

Imagine art influenced by street graffiti, California hot rod and biker scenes, comic strips, animation, punk rock, pulp fiction, and other "low brow" images. Very Dada.

Today, artists such as Ausgang, Biskup, the Clayton brothers, Shag, XNO, and Samaris have ventured back to representation, but with ironic, rebellious, and surrealist twists.

In Isabella Samaris's *Secrets of the Bat Cave*, Batman and Robin embrace in a seductive but squeamish kiss that leaves the viewer startled and curious about the superheros' secret lives.

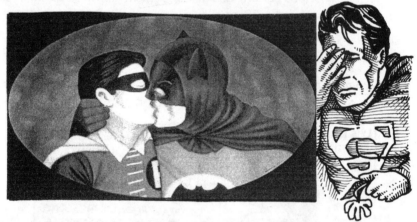

In *Samantha and the Darrins*, the artist co-opts sitcom star Elizabeth Montgomery's lovable role as a suburban witch and paints her as a nude with the two Darrins lustfully scheming behind her.

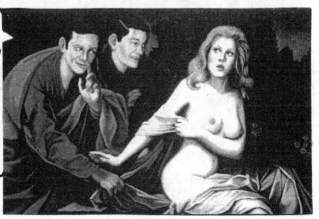

I SUPPOSE THE MALE VIEWERSHIP OF THIS SHOW HAD THESE THOUGHTS ABOUT SAMANTHA, BUT IT TOOK A POP SURREALIST TO LET ME EXPRESS THOSE THOUGHTS.

In *Kittens*, Marion Peck creates a disturbing twist as she adds a third eye to the forehead of each of two kittens, decentering the sentimental artistic cliché of kittens posing in a basket of yarn. The effect of her sweet clichéd mass-produced kittens, each boasting three eyes, is all at once disturbing, wince-worthy, and comical.

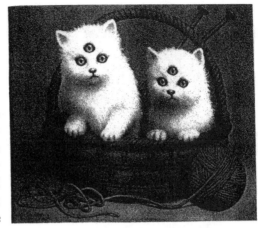

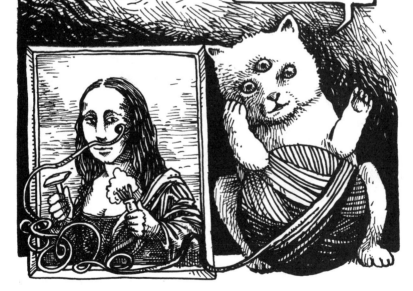

I'M NOT SO CUTE ANYMORE. I'M LIKE THE MUSTACHED MONA.

So...as a traveler who set forth to discover Dada, or the Secrets of the Magical Surrealist Art, you may have discovered them in this book.

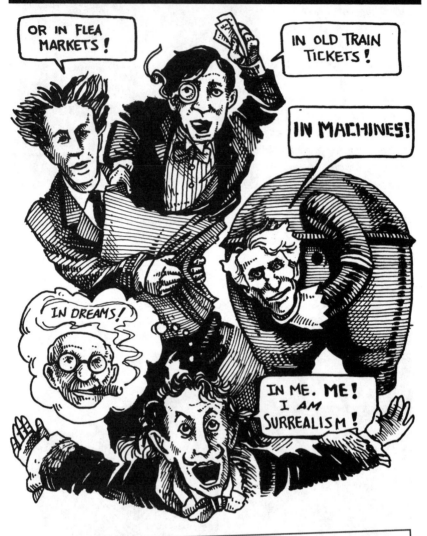

As a modern person, you may continue to discover the marvelous in advertising, film, comic books and web sites. May you continue your marvelous journey.

BIBLIOGRAPHY

Anderson, Mary (ed). *Pop Surrealism: The Rise of Underground Art*
San Francisco: Ignition Pub. / Last Gasp, 2004.

Andrews, Wayne. *The Surrealist Parade*
New York: New Directions, 1990

Aragon, Louis. *Treatise on Style = Traité du Style*
trans. by Alyson Waters
Lincoln: University of Nebraska Press, 1991

Arp, Jean. *Arp on Arp: Poems, Essays, Memories*
trans. Joachim Neugroschel; Marcel Jean, ed.
New York: Viking Press, 1972

"American Masters: Man Ray"
American Masters on PBS
<http://www.pbs.org/wnet/americanmasters/database/ray_m.html>

Ball, Hugo. "Dada Manifesto"
<http://www.391.org/manifestos/hugoball_dadamanifesto.htm>

Beilharz, Johannes, trans. "Poems by Richard Huelsenbeck"
2000
<http://www.jbeilharz.de/huelsenbeck/rh_poems.html>

Bigsby, C. W. E.. *Dada & Surrealism*
London: Methuen, 1972

Bourgeau, Jef "Art Damage: N Night of Creative Destruction in Detroit"
19 October 2005
Metrotimes: Detroit's Weekly Alternative
<http://www.metrotimes.com/editorial/story.asp?id=8366>

Brandon, Ruth. *Surreal Lives : The Surrealists, 1917-1945*
New York: Grove Press, 1999)

Breton, André with André Parinaud. *Conversations : The Autobiography of Surrealism.*; trans. Mark Polizzotti
New York: Paragon House, 1993

Breton, Andre. *Manifestos of Surrealism*
trans. Richard Seaver and Helen R. Lane
Ann Arbor: The University of Michigan Press, 1969

Breton, Andre. *Nadja*
trans. Richard Howard
New York: Grove Press, 1960

Breton, Andre. *What is Surrealism? Selected Writings*
ed. Franklin Rosemont
New York: Monad, dist. by Pathfinder Press, 1978

Buell, Tim. "*Dada Online*"
19 March 1998
<http://www.peak.org/~dadaist/English/Graphics>

Caws, Mary Ann, ed. *Surrealism*
London: Phaidon Press Limited, 2004

Caws, Mary Ann, ed. *Surrealist Painters and Poets: An Anthology*
Cambridge: MIT Press, 2001

Chadwick, Whitney. *Women Artists and the Surrealists Movement*
Boston. Little, Brown, 1985

Cork, Richard "Eye of the Beholder"
Tate Magazine, Issue 3
http://www.tate.org.uk/magazine/issue3/eyeofthebeholder.htm

Dalí Museum
2005
<https://www.salvadordalimuseum.org/ >

Elger, Dietmar *Dadaism*
Koln, London, Los Angeles, Madrid, Paris, Tokyo: Taschen, 2004

Erickson, John D. *Dada: Performance, Poetry, and Art*
Boston: Twayne Publishers, 1984

Four Dada Suicides: Selected Texts of Arthur Cravan, Jacques Rigaut, Julien Torma & Jacques Vaché
London: Atlas, 1995

Gale, Matthew. *Dada & Surrealism*
London: Phaidon Press, 1997

Gershman, Herbert S *The Surrealist Revolution in France*
Ann Arbor: University of Michigan Press, 1969

Green, Christopher "Classics in the History of Psychology"
York University, Toronto, Ontario

"The Interpretation of Dreams" Sigmund Freud 1910
<http://psychclassics.yorku.ca/Freud/Dreams/dreams3.htm>

Hoffman, Irene H. "Documents of Dada and Surrealism: Dada and Surrealist
Journals in the Mary Reynolds Collection"
Art Institute of Chicago: Ryerson and Burnham Libraries
< http://www.artic.edu/reynolds/essays/hofmann.php>

Jones, Jonathan "What the Nazis Didn't Want You To See"
16 August 2005
Guardian Unlimited
<http://www.guardian.co.uk/arts/features/story/0,11710,1549924,00.html?gusrc
=rss>

Josephson, Matthew. Life Among the Surrealists
New York: Holt, Rinehart and Winston, 1962

Kachur, Lewis. Displaying the Marvelous : Marcel Duchamp, Salvador Dalí, and
Surrealist Exhibition Installations
Cambridge, Mass. : MIT Press, 2001

Knabb, Ken (tr). "A User's Guide to Detournement"
Les Lèvres Nues #8 (May 1956)
Bureau of Public Secrets
<http://www.bopsecrets.org/SI/detourn.htm#N_1_>

Kuenzli, Rudolf E. Dada and Surrealist Film
New York: Willis, Locker & Owens, 1987

Klingsohr-Leroy, Cathrin Surrealism
Koln, London, Los Angeles, Madrid, Paris Tokyo: Taschen, 2004

Melly, George Paris and the Surrealists
London: Thames and Hudson, 1991

Mink, Janis Marchel Duchamp: Art as Anti-Art
Koln: Benedikt Taschen: 1994

Montagu, Jemima The Surrealists: Revolutionaries in Art and Writing 1919–
1935 London: Tate Publishing, 2002

Marcel Jean, ed. The Autobiography of Surrealism
New York: Viking Press, 1980

Marinetti, F.T.. "The Founding and Manifesto of Futurism"
Le Figaro, 1909 14 June 2002
<http://www.unknown.nu/futurism/manifesto.html>

Marinetti, F.T.. "War, the World's Only Hygiene"
14 June 2002
<http://www.unknown.nu/futurism/war.html>

Matthews, J.H. (tr). *The Custom House of Desire: A Half-Century of Surrealist Stories*
Berkley and Los Angeles: University of California Press, 1975

Motherwell, Robert. *The Dada Painters and Poets: An Anthology*
New York: Wittenborn Schultz 1951
now Wittenborn Arts Books, San Francisco. www.art-books.com

Klingsohr-Leroy, Cathrin *Surrealism*
Koln, London, Los Angeles, Madrid, Paris Tokyo: Taschen, 2004

Melly, George *Paris and the Surrealists*
London: Thames and Hudson, 1991

Mink, Janis *Marchel Duchamp: Art as Anti-Art*
Koln: Benedikt Taschen: 1994

Montagu, Jemima *The Surrealists: Revolutionaries in Art and Writing 1919-1935* London: Tate Publishing, 2002

Nadeau, Maurice. *The History of Surrealism*
trans. Richard Howard
New York: Macmillan, 1965

112} Naumann, Francis M. *Making Mischief: Dada Invades New York*
New York : Whitney Museum of American Art, distributed by Harry N. Abrams, 1996

Naumann, Francis M. *New York Dada 1915-1923*
New York: Abrams, 1994.

Néret, Gilles *Dalí*
Koln: Benedikt Taschen Verlag/Barnes and Noble Inc., 2000

Paquet, Marcel. *Magritte*
Koln, London, Los Angeles, Madrid, Paris, Tokyo: Taschen, 2000

Poling, Clark V. *Surrealist Vision & Technique : Drawings and Collages From the Pompidou Center and the Picasso Museum, Paris*
Atlanta, Ga.: Michael C. Carlos Museum at Emory University, 1996

Richter, Hans. *Dada: Art and Anti-Art*
New York: Harry Abrams, Inc., 1965

Rusmann, Frieder. "Manifesto for the Natural Death of the Work of Art"
trans. by Gabriele Keltsch
March 28 2001
http://www.391.org/

Salvador Dalí Museum
<http://www.salvadordalimuseum.org/>

Shipe, Timothy "The International Dada Archive"
The University of Iowa Libraries
2005
<http://www.lib.uiowa.edu/dada/archive.html>

Tzara, Tristan "Dadaism"
from "Dada Manifesto" [1918] and "Lecture on Dada" [1922]
trans. Robert Motherwell, *Dada Painters and Poets*
New York: reprinted by permission of George Wittenborn, Inc.)
<http://www.english.upenn.edu/~jenglish/English104/tzara.html>

Tzara, Tristan "Dada Manifesto"
<http://www.391.org/manifestos/tristantzara_dadamanifesto.htm>

Umlaud, Anne *Pop Art: Selections from the Musuem of Modern Art*
New York: Museum of Modern Art, 1998

Wenzel, Angela *The Mad Mad Mad Mad world of Salvador Dalí*
Munich; New York: Prestel, 2003

AUTHORS:
Peter Bethanis is an artist, essayist, and poet whose
work has appeared widely in literary journals, including
Poetry, Lullwater Review, and *Tar River Poetry.* Elsa
Bethanis is a writer and former editor whose work has
also appeared in a number of literary journals. They
reside in Indianapolis with their daughter Katie.

ILLUSTRATOR:
Joe Lee is the illustrator of many For Beginners®
books such as *Post Modernism For Beginners*® and
Eastern Philosophy For Beginners®.